PORTRAITURE IN PARIS AROUND 1800

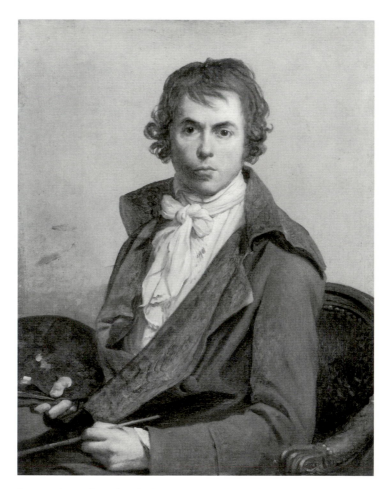

Jacques-Louis David, *Self-Portrait,* 1794. Musée du Louvre, Paris.
Photo: RMN

Portraiture
IN PARIS AROUND 1800

Cooper Penrose by
Jacques-Louis David

Philippe Bordes

TIMKEN MUSEUM OF ART, SAN DIEGO, CALIFORNIA

This catalogue accompanies the exhibition of the same name, presented at the Timken Museum of Art, October 17, 2003– February 15, 2004.

Distributed by the University of Washington Press, P.O. Box 50096, Seattle, WA 98145

ISBN: 1-879067-07-2

Library of Congress Control Number: 2003111271

Cover: Jacques-Louis David, *Portrait of Cooper Penrose* (detail), plate 2

EDITORS: Judith Dunham and Fronia W. Simpson
PROOFREADER: Louise Chu
DESIGN: Gordon Chun Design

Printed in Hong Kong through Overseas Printing, San Francisco

Contents

LENDERS TO THE EXHIBITION

Assemblée Nationale, Paris

The Frick Collection, New York

The J. Paul Getty Museum, Los Angeles

The Metropolitan Museum of Art, New York

Petit Palais, Musée des Beaux-Arts de la Ville de Paris

Private collection

Smith College Museum of Art, Northampton, Massachusetts

Wadsworth Atheneum, Hartford, Connecticut

CONTRIBUTORS TO THE EXHIBITION

Portraiture in Paris Around 1800: Cooper Penrose by Jacques-Louis David has been made possible through generous underwriting from The Friends of the Timken and the Patrons of the Prado.

The exhibition catalogue is supported by a grant from the Samuel H. Kress Foundation.

Additional support was provided by the following contributors:

THE PARKER FOUNDATION

The De Falco Family Foundation

Dr. Charles C. and Sue K. Edwards
J. W. Sefton Foundation

Sally Stevens Jones
Jane Bowen Kirkeby

Katherine Kaufman
Mr. and Mrs. William R. MacKenzie
Mr. and Mrs. J. Douglas Pardee
B. J. Curry Spitler
Amparo Valenzuela
Therese Truitt Whitcomb

Anonymous
Dr. and Mrs. Arthur Austin
Charles H. Cutter
Edele P. de Kirby
Dr. and Mrs. Charles Eller
Jodie and Lee Estep
Madeline L. Goldberg
John and Connie Hucko
David and Nancy James
Joseph Jessop Jr.
Philip M. Klauber
Thomas R. Ladner
John and Mary Beth Petersen
Mary Lou Peterson
Lois S. Roon
Mrs. Thomas P. Sayer
Mr. and Mrs. Fred Stalder
Elizabeth and Joseph Taft
John and Lavinia Thiele
Bob and Ginger Wallace
Marion C. Wilkinson

Over the past two decades, the Timken's ongoing series of focus exhibitions has stimulated new insights into, and appreciation for, the paintings in the collection of the Putnam Foundation. In the development of these exhibitions, we have had the pleasure and good fortune of collaborating with a talented group of guest scholars. Their charge has been to create a thoughtful exhibition context for a Putnam Foundation painting and, through an accompanying catalogue, to support their conceptual premise and foster scholarly discourse.

Context is key to the focus exhibitions. The appropriate or ideal context is sometimes immediately clear. More often than not, however, paintings offer up multiple contextual possibilities. Such is the case with *Portrait of Cooper Penrose* by Jacques-Louis David. Considered the preeminent painter of his day, David is best known for historical paintings of the 1780s that not only made him a central figure of the neoclassical movement, but also came to symbolize the values and underlying sentiments of the French Revolution. Although David painted portraits throughout his career, their number is not great. The Putnam Foundation's *Portrait of Cooper Penrose*, which is representative of his mature style, dates to a historically complex period in French history, the years between the Revolution and the Empire.

In formulating a context that would provide an informed look at this painting, guest scholar Philippe Bordes, professor of art history at the University of Lyon 2 and founding director of the Musée de la Révolution française, Vizille, gave thoughtful and extended consideration to several approaches. One was placing the Penrose portrait within a selection of paintings that could trace, in summary form, the history of French portraiture. Another was to position *Portrait of Cooper Penrose* within a small selection of David's portraits.

The course chosen, as revealed by the exhibition and catalogue, was to situate *Portrait of Cooper Penrose* within a narrow context of time and place: Paris during the period of the Consulate. The result is provocative and illuminating. The assembled portraits, produced within a five-year period, yield an especially rich viewing experience, prompting a consideration of elegant similarities and contrasts, and capturing, through both expression and attire, a particular moment in time.

The scholarship and precision Dr. Bordes has brought to the catalogue expands upon recent commentaries, affords new insights into David's art around 1800, posits provocative biographical considerations, and sheds light on the role of women in the Parisian art scene at this time. His essay superbly fulfills the ambitions of a focus exhibition publication. We are extremely grateful to Dr. Bordes for his invaluable efforts on behalf of the Timken.

Two other observations are in order. The Putnam Foundation acquired *Portrait of Cooper Penrose* in 1953, exactly fifty years ago. It was the third painting to come into the foundation's collection. David's portrait of Penrose was not well known, having remained in the Penrose family from the time it was commissioned until 1947, when it was sold to Wildenstein & Co. That this fine portrait would come to reside in San Diego, far from its ancestral home in Cork, Ireland, and distant from the museums and private collectors of New York, was indeed fortuitous. Coincidentally, Cooper Penrose's family papers now reside just a few miles north of the Timken Museum, in the possession of descendants who have also made their way to Southern California.

This exhibition and catalogue have benefited from the work of several individuals. We extend our thanks to Suzanne and Gordon Chun, catalogue designers, Judith Dunham and Fronia Simpson, catalogue editors, as well as Christine Sullivan, Louise Chu, and Erick Gude.

The cooperation of public institutions and private lenders was essential. We join with Philippe Bordes in offering our thanks to the staff and trustees of the lending institutions for their generosity and cooperation. We also extend our gratitude to the individuals and foundations whose contributions have supported this project. Finally, we give special thanks to the Samuel H. Kress Foundation for providing generous underwriting of the catalogue.

John A. Petersen
Executive Director

Hal Fischer
Director of Exhibitions and Publications

ACKNOWLEDGMENTS

This project received the support of John A. Petersen, Executive Director of the Timken Museum of Art, and the Board of Directors of the Putnam Foundation. Hal Fischer, Director of Exhibitions and Publications, assured the administrative and logistical backup and offered much constructive criticism along the way.

In the course of examining different pictures, a number of museum professionals were most welcoming and accommodating: Edward Russo, Eric Zafran, Cindy Roman, and Keith A. Stevenson at the Wadsworth Atheneum (Hartford), Scott Schaefer at the J. Paul Getty Museum (Los Angeles), Colin B. Bailey at the Frick Collection (New York), Gary Tinterow at the Metropolitan Museum of Art (New York), Linda Muehlig at the Smith College Museum of Art (Northampton), Jean-Pierre Cuzin and Marie-Catherine Sahut at the Musée du Louvre (Paris), Gilles Chazal and Isabelle Collet at the Musée du Petit Palais (Paris), Lynn Federle Orr and Marion C. Stewart at the Fine Arts Museums of San Francisco, Alain Chevalier and Annick Le Gall at the Musée de la Révolution française (Vizille), and James Welu, Deborah Diemente, Jordan Love, and Janet Manahan at the Worcester Art Museum (Worcester). In Paris the three *quæstors* of the National Assembly, Henri Cuq, Claude Gaillard, and Didier Migaud, and their assistant for the art collection, Claire Rondeleux, were most cooperative. All those who were responsive to the theme of the exhibition and agreed to lend works deserve special gratitude.

During the search for works to exhibit and ideas to explore, a number of friends, colleagues, and contacts made useful suggestions or furnished timely information and photographs: Alexander Babin, Monika Bachtler, Joseph Baillio, Jeannine Baticle, Patrice Bellanger, Cécile Bernard, David Bindman, Thierry Bodin, Etienne Bréton, John Goodman, Gregory Hedberg, Susan Hood, Mehdi Korchane, Anne Lafont, Cyril Lécosse, Mark Ledbury, Christophe Marcheteau de Kalinsmarck, Max (J. P.) McCarthy, Christian Michel, Myriam Pinon, Richard Rand, Catherine Régnault, Petra Reisterer, Chris Riopelle, Sandra Romito, Tim Warner-Johnson, Kathleen Watchorn, Stephan S. Wolohojian, and Pascal Zuber. The texts for the catalogue benefited from an attentive reading by Louise Chu, Judith Dunham, and Fronia W. Simpson.

Ph.B.

Que Monsieur Penrose se fie entièrement à moi, je lui ferai son portrait pour deux cents louis d'or. je le représenterai d'une manière digne de tous les deux. ce tableau sera un monument qui attestera a l'Irlande les vertus d'un bon père de famille, et les talens du peintre qui les aura tracés.

On s'acquittera en trois payemens. savoir 50 louis en commençant, 50 louis quand le tableau sera ébauché, et les 100 louis restans quand l'ouvrage sera achevé.

Undated letter from Jacques-Louis David to Cooper Penrose contracting for the latter's portrait commission.
Timken Museum of Art

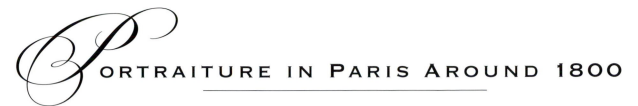
PORTRAITS BY DAVID, 1795–1802

More than any other artist active during the eventful years from the assault on the Bastille in 1789 to the fall of Robespierre and the end of the Terror in 1794, Jacques-Louis David (1748–1825) became deeply involved in the quotidian politics of the French Revolution.[1] In the autumn of 1792 the painter became a full-time elected politician. He willingly put his art at the service of the new civic and republican ideals of the period, participating not only in the workings of government but also in the judicial operations of the Jacobin Terror. Following the overthrow of this regime during the summer of 1794, he had reason to feel a share of responsibility for harsh measures of repression. After David had a close call with the guillotine because of his public support for Robespierre and spent a full year in prison, his slate was clean in the eyes of the law. Voices continued to be heard, however, associating him with the revulsive acts of the recent past. In coming to terms with his involvement in the Terror, David manifested neither the cynicism nor the self-righteousness that many of his contemporaries used to salve their conscience. Smarting from that difference, he admitted to having been deceived by Robespierre's rhetoric but protested that he had not been alone. After Thermidor,[2] the extremes of the suffering poor and the parading rich that characterized the Parisian scene probably reinforced the sentiment he was to express freely later in life: although the Jacobins had been misled, their democratic and social ideals remained attractive. David's reaction was less one of denial than of displacement, away from the political arena toward the artistic realm, where he wanted to fulfill his destiny both as an artist and as a citizen of the new French Republic.

David's reintegration into the society of artists, critics, and patrons in which his preeminence had been recognized and consecrated during the 1780s is heralded by the self-portrait reportedly painted in the autumn of 1794 during his imprisonment (frontispiece): he grips the palette and brush of the painter, as if seeking to imitate the Roman and Sabine warriors with their shields and weapons that filled his imagination at the time. But the battle he was readying to wage embraced a different cast of characters and context from what he had known before the Revolution. The talented history painters of his generation—François-André Vincent (1746–1816), Pierre Peyron (1744–1814), and Jean-Baptiste Regnault (1754–1829)—had not adapted well to the practice of art as it was drastically reformulated after 1789: these academicians were now deprived of the security and confidence that royal privilege had provided. Artists were now all on their own. The academy was dissolved in 1793, open contests were organized to award official commissions, and since 1791 there were few if any restrictions to show at the Salon. The elders continued to paint, exhibit, and run studios, but their moral exhaustion was patent. Significantly, right after Thermidor, none managed in any notable way to profit from David's disgrace. In this context, David's capacity for staging a comeback after being publicly vilified and imprisoned is all the more remarkable.

David's liberation in the autumn of 1795 coincided with the advent of a new regime run by an executive committee of five officials (the Directory), elected by two consultative assemblies. For four years, it swayed between pressure from royalists on the right and neo-Jacobins on the left. During this period, the government continued to extol republican ideals and even deployed a rhetoric of patriotism reminiscent of the Terror when there was threat of foreign invasion. Nevertheless, wealth, especially property acquired during the Revolution, became the selective criterion for participation in public life. The new government encouraged private cultivation of the arts and the luxury trade. This tended to relegitimize certain aristocratic practices of the Ancien Régime, such as renovating interiors, collecting art, commissioning portraits, and keeping up with fashion, which the Jacobin government, inspired by the writings of Jean-Jacques

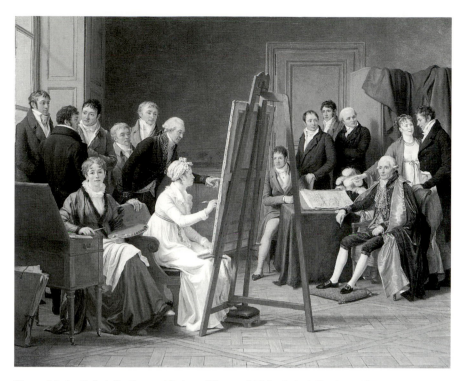

Fig. 1. Marie-Gabrielle Capet, *Madame Vincent [Adélaïde Labille-Guiard] Painting the Portrait of Joseph-Marie Vien,* 1808 (Salon of 1808). Alte Pinakothek, Munich. Photo: ARTOTHEK, Weilheim

Rousseau, had castigated. Not since the adulation of rococo artisans in the 1730s had commercial values been so explicitly emphasized and the marketplace invoked as the remedy for the nation's woes. A profoundly republican critic, Jean-Baptiste Pierre Chaussard, attempted to restore the confidence of artists with his *Essai sur la dignité des arts* in 1798, but just the next year he was moved to devote a celebratory ode to *L'industrie ou les Arts de l'industrie.* In September 1798 a first *Exposition des Produits de l'Industrie française* was organized, but it was on the Champ-de-Mars, far from the center of town. When it was repeated in 1801 and 1802, it was held for only one week in the Louvre courtyard and directly rivaled the Salon.[3] During the late Directory and Consulate, perhaps in reaction to this pressure, the traditionally biennial Salon was organized on an almost annual basis and could be seen in 1793, 1795, 1796, 1798, 1799, 1800, 1801, 1802, and 1804. Whereas prior to the Revolution the Salon had been a costly enterprise in service to the prestige of the monarchy, its primary function after Thermidor seems to have been more prosaic, a way for

artists to promote their talent in the eyes of potential clients. Successive ministers of the interior in charge of the Salon continued to laud the fine arts for their lofty moral purpose, but the official attention accorded to the *arts de l'industrie,* as the decorative arts were designated, obliged painters and sculptors to confront the economic and financial realities of their activity more openly than they had during the Ancien Régime.

The artistic scene during these years was dominated by several of David's former students, most prominently Jean-Baptiste Isabey (1767–1855), Anne-Louis Girodet (1767–1824), François Gérard (1770–1837), Antoine-Jean Gros (1771–1835), and Philippe-Auguste Hennequin (1763–1833), and by others such as Pierre-Narcisse Guérin (1774–1833), from Regnault's studio, who espoused his critique of the "French manner" (the expression commonly employed to deride the pervasive mid-eighteenth-century style of painting later known as rococo). These young men were torn between adopting the artistic ambitions of their masters—in other words, producing history paintings that traditionally gauged the moral spirit of the nation but

for which there was no demand—and addressing the needs of private consumption. "Since history painters also need to make a living, Gérard, like several of his colleagues, has also painted portraits," noted one foreign observer of the contemporary art scene in Paris in 1803–4.[4] This meant catering to a broad range of patrons (for portraits in various media, small genre scenes, and landscapes) and to the print and book trade (for illustrative compositions destined to be engraved). Artists solicited official encouragement from the government to fulfill their high ambitions, while appropriating the values of the new elite to reach their clientele. Isabey, in particular, knew how to attract and reassure the nouveaux riches; he publicized his fashionable lifestyle and rarely refused demands for private drawing lessons.

In October 1795 David had every reason to believe that the woes resulting from his Terrorist activities were over: he benefited from a general amnesty and was nominated by the Directory to the Institut national des Sciences et des Arts, an exclusive institution created to mediate between the professions and the government. This nomination amounted to an official announcement of his full reinstatement into the social, political, and cultural order of the new regime. Al-

though David participated in the meetings of the beaux-arts section of the institute, especially when the Rome Prize for his students was at stake, he kept mostly to his studio and let his former master, Joseph-Marie Vien (1716–1809), along with Vincent and Regnault, who were also members, exert their influence (fig. 1).[5] He also kept his distance from the group of younger artists who rallied around Isabey, which a painting by Louis-Léopold Boilly (1761–1845) at the Salon of 1798 (fig. 2) successfully promoted. David's rivalry with Isabey was a commonplace. One informed observer in 1800 evokes this in terms of "party" opposition.[6]

Nonetheless, David seems to have analyzed the post-Revolutionary situation in the same terms as did other artists: the demand for portraits was greater than ever, while that for moralizing historical subjects was scarce and, on a grand scale, nonexistent. Nor could he ignore the offensive launched by Pierre-Paul Prud'hon (1758–1823) and a number of lesser painters to promote a more lyrical and Anacreontic vision of antiquity, a concerted revival of amorous themes associated with the "French manner" but in a classicizing mode. During the last months of 1795, David decided to illustrate on a vast scale a subject from the mythical foundation of the Roman Republic, *The Intervention of the*

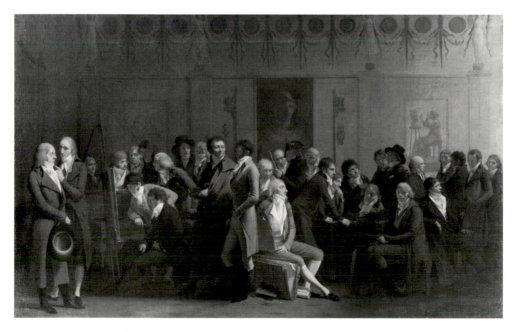

Fig. 2. Louis-Léopold Boilly, *Reunion of Artists in Isabey's Studio* (Salon of 1798). Musée du Louvre, Paris. Photo: RMN

Sabine Women, a painting he finished only in 1799 (fig. 3). To compensate for the lack of a patron or a commission for this project, David installed, with the help of the government, a personal exhibition in the Louvre and charged an entrance fee in the hopes of covering his costs. Wanting both protection and independence was characteristic of David's capacity to ally high ideals with a keen sense of opportunism and pragmatism. Public curiosity, his preeminent reputation, and the general recognition of the superior talent manifest in his painting helped make the exhibition a success. Several painters and even a sculptor hastened to imitate his entrepreneurial initiative, but the Parisian public seemed to have been notably less interested.

Work on *The Intervention of the Sabine Women* did not deter David from accepting portrait commissions. Fresh out of prison, he may have wanted to restore both his finances and his confidence through such work; he probably also sought to rekindle a sense of community with supportive patrons. In 1795–96 he

painted portraits of two representatives of the Batavian Republic (the Netherlands) present in Paris to negotiate the terms and cost of the French military occupation of their country (figs. 8, 9). Jacobus Blauw, one of the two, explained in a letter to the painter why he had been so eager to sit for him: "Don't think, dear friend, that the sole desire to have my portrait prompted me to engage you. No: I esteemed you more than myself; I wanted to possess one of your masterpieces and I wanted even more for this portrait to be a monument for eternity to my intimacy with the foremost painter in Europe."[7] Although these were soothing words, David probably did not need such prodding to practice a genre considered inferior to history and associated with degrading commercial values. From the outset of his career, when he painted a series of family portraits, to the end of his life, when the dire circumstances of exile led him to produce at least six portraits in one year (1816), in no instance was David reluctant to devote himself to such work. That the

Fig. 3. Jacques-Louis David, *The Intervention of the Sabine Women* [*The Sabines*], 1799. Musée du Louvre, Paris. Photo: RMN–R. G. Ojeda

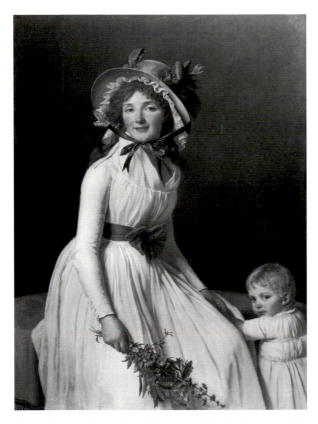

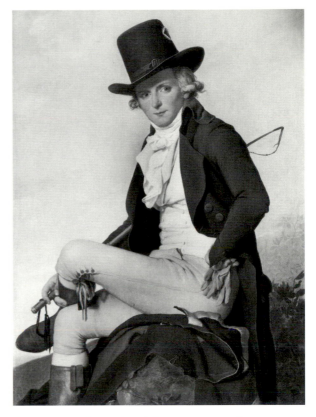

Fig. 4. Jacques-Louis David, *Portrait of Emilie Sériziat and Her Son Emile,* 1795 (Salon of 1795). Musée du Louvre, Paris. Photo: RMN–Gérard Blot

Fig. 5. Jacques-Louis David, *Portrait of Pierre Sériziat,* 1795 (Salon of 1795). Musée du Louvre, Paris. Photo: RMN–Gérard Blot

younger generation and certain critics during the Directory encouraged the investment of artistic ambition in portraiture, as Tony Halliday has shown, seems literally to have pushed David to want to surpass his rivals and himself.

The portraits of his wife's younger sister, Emilie Sériziat (fig. 4), and her husband, Pierre Sériziat (fig. 5), illustrate the competitive attitude that fashioned David's portrait practice. Having found repose in the Sériziats' country home when he was released from prison, David set to work finishing a portrait of Emilie and her child, which he may have begun during an earlier stay. It is an astonishingly fresh image that celebrates the leisurely pleasures of his newfound freedom. The young woman, whose expansiveness is disarming, is posed casually on the edge of a cloth-covered table and appears to have just returned from a walk: she holds a bouquet of wildflowers in one hand, her child with the other. The painting is accomplished

but *retardataire:* the relaxed portraits of aristocratic beauties during the 1780s by Elizabeth Vigée Le Brun (1755–1842) come readily to mind, although David has trimmed their residual coyness. Also recalling her art is the panel support, which heightens the warm vibrancy of the colors and the flushed complexion of the sitter. Manifestly, David is tempted by a Rubensian exuberance: Emilie's eyes sparkle and her lips show off a row of glistening teeth. *Henriette de Verninac,* painted just four years later (fig. 10), seems to be a programmatic antithesis to *Emilie Sériziat* and suggests that David became aware of the need to convey more exactly the cool reserve of the post-Thermidorian moment that Gérard and Isabey captured so well in their portraits. The composite character of the portrait of his sister-in-law is striking. The flowers rendered with Dutch precision, the stylish, complicated hat (woven straw, lace, and cut ribbons of different shades), the creamy white dress, the abstract scratches and

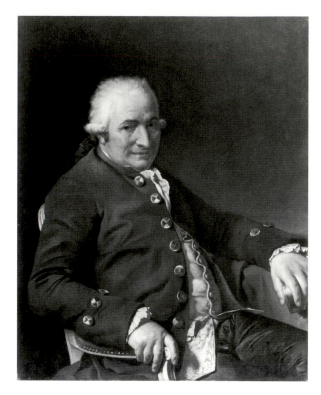

Fig. 6. Jacques-Louis David, *Portrait of Charles-Pierre Pécoul,* 1784 (Salon of 1785). Musée du Louvre, Paris. Photo: RMN

scumbling from a stiff brush (*frottis*) in the background, and the densely painted red tablecloth each pull the painting in different directions. To contemporary eyes informed by academic principles of pictorial unity, David's execution, however masterly, could not fail to appear indecisive and unresolved.

More coherent is the portrait of Pierre Sériziat, painted just after that of his wife. Tighter and more virtuoso in handling, it is a daring tour de force as it re-creates the flattening effect of strong outdoor light. Even more explicitly than its companion portrait, it illustrates the freedom to roam the countryside and a worldly sense of control and confidence. Not surprisingly, David had never felt the lure of nature more strongly than in prison, where he painted a landscape, a singular initiative in his oeuvre, which was otherwise always concentrated on the human figure. He appears to have labored over the portrait of Sériziat. On a promontory, unmindful of the prickly brambles under his cloak,[8] the sitter seems less relaxed than his wife; his is a mannered, self-contained pose that claims a distant filiation with Michelangelo and Raphael and

creates a sense of cultural authority befitting a man. His stylish Anglophile riding outfit, a distinctive sign of modern living, and his appreciation of natural surroundings acknowledge the changes that had transformed Parisian art and society since 1794. When commemorating the popular figure of Marat in 1793 (fig. 16), David had underlined the assassinated deputy's scorn for material concerns and the pleasures of life, his sense of abnegation and sacrifice. With the pair of Sériziat portraits two years later, the painter celebrates an opposing set of values in the public arena of the Salon: the two *citoyens* may sport a republican cockade on their hats, but they are well on their way to becoming *fashionables.*[9]

Contemporaries had mixed reactions to the material values championed during the Directory and the Consulate, as new wealth and the conspicuous consumption that went with it became more ostentatious. A social order rewarding merit and an economy encouraging private initiative were considered a blessing. However, some were critical of the "nouveaux enrichis"; a German visitor to Paris in 1803–4 found unrepublican the arrogant manners of these vulgar Frenchmen, "les fournisseurs de la république," who ignored the politeness that had characterized high society before 1789.[10] The reign of the blind Roman god of riches, Plutus, would last almost a decade. Napoléon's imperial regime would finally return to a policy of economic intervention (including in the domain of the arts) and promote a quite different social mythology capable of reconciling the French around the emperor. This would be a strange but effective combination of values: an aristocratic fantasy of court and nobility pretending to moralize the image of the elites, and a democratic fantasy inherited from the Revolution, founded on military values and a sense of national pride.

As David shifted brushes from *Marat* to *Sériziat* in the span of two years, his change of mind was not as extreme as one might think. He had paid a sincere homage to a fellow deputy at the Convention struck down by an assassin. During the Terror he had publicly taken a stand against the radical Rousseauism inspiring Jean Paul Marat, the sansculottes, and the Jacobins in their attacks on the corruptive luxury of the arts. David considered himself invested with a

responsibility toward the fine arts and never fully aligned himself either with Marat, who was too populist, or with Robespierre, who was too iconophobic. In the portraits of Emilie and Pierre Sériziat painted in 1795, he invokes the cult of nature dear to Rousseau but in terms of fashion, much like society portraitists of the 1780s. The real novelty of his position, echoing his cathartic passage from public stage to jail and then to studio, is the celebration of that private conception of freedom and happiness articulated at the time by Benjamin Constant against the collective definition, with its attending sacrifices, which the Jacobins had extolled.[11]

David had painted pendant portraits of Emilie's parents in 1784 (her father, fig. 6). Confronted with the same objective a decade later, he was not particularly concerned with a perfect match. The viewer looks down on the woman and up at the man. It has been argued that stressing gender differences in the portraits of the Sériziat couple was therapeutic for David's recovery from his painful self-examination in prison.[12] It seems, however, that he was not particularly more emphatic about such a differentiation in 1795 than he had been in 1784 nor, for that matter, than most painters had been since the Renaissance. The image of Sériziat with his overly sweet face might even be considered one of the most effeminate of David's male portraits. Sériziat seems absolutely foppish compared with Isabey in Gérard's portrait, painted the same year (fig. 7).[13] Both men wear fashionable riding clothes, but Isabey's outfit is subdued in color, as if worn, compared with Sériziat's new clothes. Eager to prove that he was still to be accounted for on the art scene, David made his pair of portraits appear conceived less as interior adornments than as pictorial statements. His familiarity with the authoritative portraits by Raphael and Titian belonging to the recently formed national collection housed in the Louvre suggested a prestigious final destination for his own works: the museum. Such self-consciousness and preoccupation with artistic referentiality help explain why the two pictures are such uneasy pendants. David was apparently more concerned with their making than with their imaging. It may also explain why Gérard waited several months, perhaps even a year, to exhibit his portrait of Isabey. The two former pupils were particularly close to

Fig. 7. François Gérard, *Portrait of Jean-Baptiste Isabey and His Daughter Alexandrine,* 1795 (Salon of 1796). Musée du Louvre, Paris. Photo: RMN–Gérard Blot

David just at this time, and in the public competition with their master, it is not clear who was giving the cue. David may have painted Pierre Sériziat with the portrait of Isabey in mind, implicitly rejecting an overdone mise-en-scène, an immodest imperviousness to social decorum. Or it may have been the other way around: seeing how old-fashioned, labored, and prettified the Sériziat couple appeared, the two pupils may have felt an Oedipal urge to demonstrate their own sense of confidence and capacity for innovation. Whichever had priority, these portraits, like others from these years (see pair by Prud'hon, figs. 28, 29), exude the freshness of the post-Revolutionary moment.

The implicit rivalry between David and Gérard was arbitrated by the test of the Salon. The contrast between the sparse critical comments inspired by the *grand maître* and his two portraits in 1795 and the effusive praise elicited by Gérard's *Isabey* in 1796

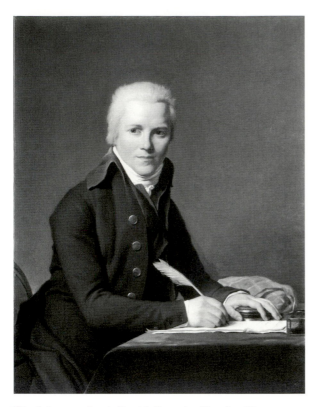

Fig. 8. Jacques-Louis David, *Portrait of Jacobus Blauw,*
1795–96 [Republican Year IV]. National Gallery, London.
Photo: museum

corresponds to the greater excitement provoked by the
latter picture. While their master abided by an Ancien
Régime sense of personal discretion, the two young
painters openly exploited their mutual support to
attract sympathy and attention.[14] Ever since the 1780s,
David had also proven himself aware of the impor-
tance of timing and staging the presentation of his
work to catch the public's eye. Unlike his younger
contemporaries, however, he was reticent to expose his
private life as spectacle. Still sore from the abuse his
political activity had provoked, he was tempted to
recoil from public view: the Salon of 1795 was the last
to which he would send a painting until 1808. In June
1800 he wrote to Raymond de Verninac, who wanted a
public showing of the recently finished portrait of his
wife (fig. 10): "I don't exhibit at the Salon for reasons
which would take too long to outline; you saw often
enough how artists treated me at the time of my mis-
fortunes and it was they who had the most reason to
thank me who oppressed me the most."[15]

This sentiment explains the sense of social isola-
tion perceptible during this period of David's life. If
one excepts visits to the pupils' studio several times a
week to inspect and comment on their work, he gives
the impression of leading a relatively quiet existence,
seeking mostly the company of collaborators and close
friends. The spectacular public initiatives he took dur-
ing these years—manifest when he exhibited *The
Sabines* for a fee and courted General Bonaparte for a
commission—seem driven by a need to compensate
for this discretion and probably to take revenge on his
detractors. This state of mind also influenced how he
regarded his portrait practice after the Revolution.
During the Ancien Régime, the commissioned por-
traitist was implicitly placed by the sitter in the inferior
role of a paid servant. In the 1780s a few painters—
Joshua Reynolds in England, Vigée Le Brun in France
—were relatively successful at establishing themselves
as the social equals of the aristocrats they painted. The
Revolution brought about a profound change in the
traditional rivalry between portraitist and sitter, each
vying for preeminence over the other. As Tony Halli-
day has stressed, the effort to present portraits as ambi-
tious works of art in their own right was a way to
enhance the professional prestige of the artist. This
was supported by the republican ideal of equality
among *citoyens,* resulting in a greater range of portrait
commissions. While these were no longer the privilege
of the rich and well born, social distinctions founded
on the reputation and fee of the artist chosen prevailed
and became more explicit. To alleviate the harsh eco-
nomic reality of an openly commercial transaction,
portraitists sought not only to raise the artistic status of
their work but also to develop an idealized relation to
their sitters. For this reason, during the Directory
artists often chose to represent family members or
close friends: the obscurity of the sitter attested to the
virtuous disinterestedness of the undertaking.

The four major portraits that David painted in
1795–96—the Sériziat couple and the two representa-
tives of the Batavian Republic, Jacobus Blauw (fig. 8)
and Gaspard Meyer (fig. 9)—helped him restore
understanding and trust in his entourage. The two
foreigners, like the painter, had a penchant for radical
politics and contemporary art. David represents each
sitting with pen in hand at a writing table, against a

neutral background. The geometry of the table clearly defines the pictorial space. Furniture, objects, and costume are disposed without clutter; description and delineation are measured. This representational poise, the sense of formal purity, the cool colors, and the dignified naturalness of the sitters, recalling David's earlier portraits, are magisterial but fundamentally conventional exercises. As with his historical projects from this period, he yearns to capture a sense of post-Revolutionary modernity in these portraits but at the same time turns the clock back to reactivate a lost momentum.

On completing *The Sabines,* David once again engaged with portraiture, more confidently than before. Manifestly, he wished to take note of the experiments and innovations introduced by Gérard, Isabey, Girodet, and others in recent years (see "Portrait Modes and Codes during the Consulate," page 20). His determination to confront the new standards of the day inspired *Henriette de Verninac* (fig. 10), finished between September 1798 and September 1799, and *Juliette Récamier* (fig. 11), on which he worked during the second half of 1800. The monumentality of the first and the scale of the second suggest a far greater artistic investment than in the portraits of 1795–96, while the quality of the sitters, who are visibly à la mode, inscribe these works in the cultural circuit of the new elite, to which David had first bowed by accepting society women as models for *The Sabines.*

Henriette de Verninac was the spouse of a high-ranking functionary, and Juliette Récamier, a much-talked-about fashion icon, the wife of a wealthy banker. David conceived these paintings as two distinct variations on the feminine ideal. In the letter to Henriette's husband asking him not to send his wife's portrait to the Salon, written in June 1800, he indicated: "I am busy right now creating another beautiful woman, Madame Récamier. It is another type of beauty completely. I suspect that she will want her portrait exhibited; when that happens, *citoyen Préfet,* I shall have the honor to inform you and by the same token request your permission to join Madame de Verninac's to the other."[16] This reveals a salient point concerning the two portraits: their complementary nature. Although different in format and in no way formal pendants, they were viewed by David as a conceptual pair. Both

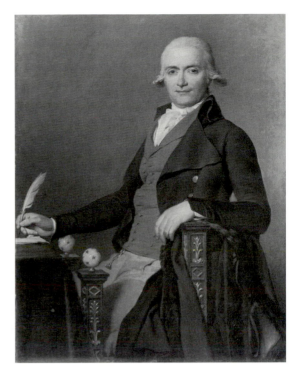

Fig. 9. Jacques-Louis David, *Portrait of Gaspard Meyer,* 1795–96 [Republican Year IV]. Musée du Louvre, Paris. Photo: RMN

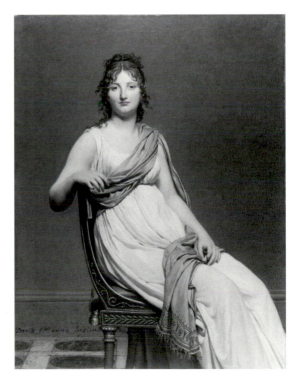

Fig. 10. Jacques-Louis David, *Portrait of Henriette de Verninac,* 1798–99 [Republican Year VII]. Musée du Louvre, Paris. Photo: RMN

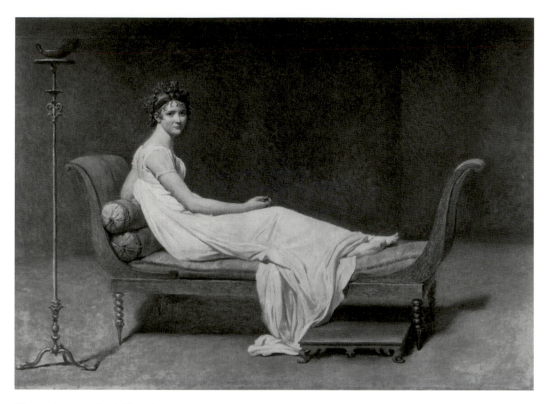

Fig. 11. Jacques-Louis David, *Portrait of Juliette Récamier*, 1800. Musée du Louvre, Paris.
Photo: RMN–Gérard Blot

women were about thirty (Henriette was born in 1780, Juliette in 1777) so the distinction was not one of youthful as opposed to mature beauty. Ewa Lajer-Burcharth has contrasted Henriette de Verninac's body shown off for inspection—"the swelling breasts with the nipples somewhat promiscuously showing through"—with Juliette Récamier's body, turned away from the viewer, access to it denied. Yet the statuesque presence and cool severity of Henriette's portrait give her an air of invulnerability rarely found in depictions of women at the time. She may descend from the Sabine women, but she does not need to replicate their drama of emotion and seduction; no other woman painted by David expresses quite the same calm grandeur.[17] To achieve this, he reinterpreted celebrated antiques he had drawn while in Italy and already put to use in the 1780s for the seated figure of Brutus: the *Seated Agrippina* in the Capitoline Museums and the so-called *Menander* today in the Vatican. Judging from the relatively consistent degree of finish throughout the picture, painting Henriette was an easy job. David

clearly found the expression of her femininity in a marmoreal mode attractive.

Painting Juliette Récamier was quite a different matter, however. In a letter to the sitter, he avowed problems capturing the expression on her face. Furthermore, the painting in the Louvre bears multiple traces of his uncertainty in structuring the space around the figure. With respect to the portrait of Juliette, he activated traditional signs of female beauty, adopting a reclining pose alluding to Venus and gracefully elongated forms, supple and elegant. And yet, the portrait fails to objectify the sitter's power of seduction, recreated by Gérard in 1805 (fig. 12) and probably also in the lost half-length he painted in 1801. Whether the problem was David's unwillingness to submit to Juliette's coy charm, well captured by Joseph Chinard as well as Gérard, or Juliette's refusal to be turned into a stone maiden, the cell-like emptiness of the unfinished painting smacks of a disastrous confrontation. As is well known, David had a falling-out with the society beauty, whom he later accused of "impatience." She

may have been capricious, but this seems to have been less the motive than the pretext for David's reaction. It is unlikely that he was perfectly happy servicing such a nouveau riche clientele, whose values were so fundamentally at odds with his artistic and civic ambitions. Neither virgins nor matrons, the fashionable women of the Directory asserted their cultural visibility with an unprecedented confidence that tended to subvert traditional male domination, as Ewa Lajer-Burcharth's revealing discussion of the question has demonstrated. It is quite possible that David may have felt threatened by Juliette's commanding beauty and by her insistence on exercising control over the flow of desire.

Although he parted ways with the Jacobins when it came to their Rousseauist critique of the corrupting influence of the arts, he was perfectly in tune with their position toward women. His was a bourgeois prudery, inspired by a moral revulsion for the libertinage of the Ancien Régime and the exaltation of patriarchal values. As several historians have noted, he was one of many painters who after the Revolution engaged in exploring the expressive possibilities of the male nude, in *The Sabines* and immediately after in *Leonidas at Thermopylae* (Musée du Louvre); clearly he was more comfortable visualizing forms of masculinity than the varied expressions of femininity. However that may be interpreted, it is patent that he chose to establish a certain distance—artistic, social, and psychological—with respect to the women he painted. His cringing nude *Psyche Abandoned* (private collection) is, as Lajer-Burcharth has insisted, an anxious performance. During this period, David's most unproblematic representation of a woman, whose informality manifests neither an anxiety of desire nor a fear of domination, is the portrait of his servant, Catherine Tallard (fig. 13). Her employer-painter seems here perfectly at ease. Perhaps the only hint of trouble, suggested by the coquettish expression of the maid—if one is to follow Lajer-Burcharth's analysis of David's libidinal investment in clothing and drapery—is the wrapping of her body almost to excess, as if begging to be undone. Why David, unlike Gérard in his 1805 portrait, chose not to adopt such conventions when painting the wife of the banker Récamier remains an open question. The social status of the sitter, which inverted the roles of master and servant inscribed in the Tallard

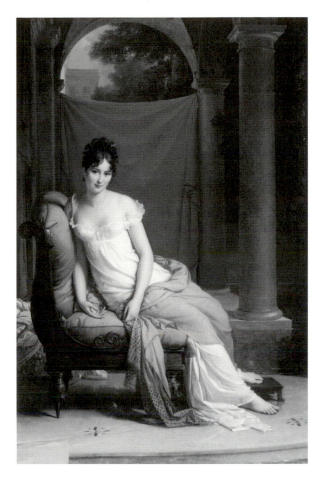

Fig. 12. François Gérard, *Portrait of Juliette Récamier*, 1805. Musée Carnavalet, Paris. Photo: © Photothèque des musées de la ville de Paris/Cliché Joffre/Degraces

portrait, and what might be termed her active, as opposed to passive, beauty are surely part of the answer.

Visitors to Paris during the Consulate reported that, unlike Gérard and Isabey, David was not to be found at society balls and fashionable cafés. One English visitor noted that he was reputed to be "a man of very unamiable disposition"; another observed, "he leads the life of a proscribed exile, in the very center of the gayest city in Europe."[18] The young Guérin, who had made such an impact with *The Return of Marcus Sextus* in 1799 (Musée du Louvre), was also known to keep to his studio, but, as is clear from the rumors of his impending marriage with Vigée Le Brun's daughter and the successive presentation of his portrait by Robert Lefèvre (1755–1830) at the Salon in 1801 and 1802, he was not averse to staging publicity stunts to maintain his popularity.[19] David's reclusion was also

relative. He willingly engaged in social exchanges when the curiosity he provoked was sympathetic. Whereas the British generally shied away from him and were receptive to aspersions they heard, one visitor from Geneva, whose nephew had been studying in David's studio for several years, was full of praise after meeting the artist in May 1802: "Good-looking figure, very regular life totally devoted to his work."[20]

The artist was open to such admirers and also careful to promote himself in official circles. Since 1796 he had been attentive to the exceptional leader emerging from among the generals of the republic, Napoléon Bonaparte. In 1797–98, during one of the latter's brief sojourns in the capital, David had even managed to secure a sitting for a historical portrait. After the coup d'état of Brumaire,[21] which overthrew the Directory and established the Consulate late in 1799, he was immediately called on to advise unofficially on artistic matters. Even though his influence waned as the new administration was organized, his admiration of Bonaparte, now First Consul, was steadfast. So when, in August 1800, a representative of the king of Spain, Charles IV, asked for a full-length portrait of Bonaparte that was destined for the Hall of the Great Captains in the royal palace in Madrid, the painter was enthusiastic. He relished celebrating the exploits of the military hero and his army crossing the Alps the preceding May, on their way to victory at Marengo (fig. 14). The success of this painting provoked an official demand for several replicas, in which David incorporated some notable changes.[22] A sense of exhilaration is manifest in this enterprise, which occupied him through 1803 and foreshadowed the two huge coronation scenes for the emperor that he would paint from 1805 (Musée du Louvre; Musée national des Châteaux de Versailles et des Trianons). In all these Napoleonic commissions, David's ambition as an artist clearly found an occasion to express itself fully. It is all the more remarkable that during this period, when his brush was glorifying an exceptional individual in an equestrian group that constituted the most elevated form of the portrait genre, he should have acceded to the solicitation of a rich but unknown Irishman visiting Paris and desirous of taking home a souvenir and a trophy: his portrait by the famous David.

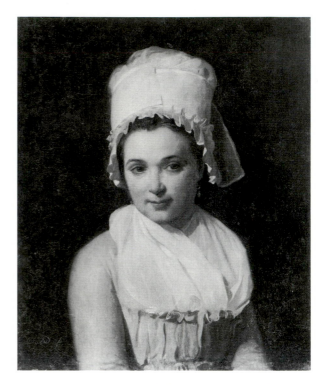

Fig. 13. Jacques-Louis David, *Portrait of Catherine Tallard*, ca. 1795. Musée du Louvre, Paris. Photo: RMN

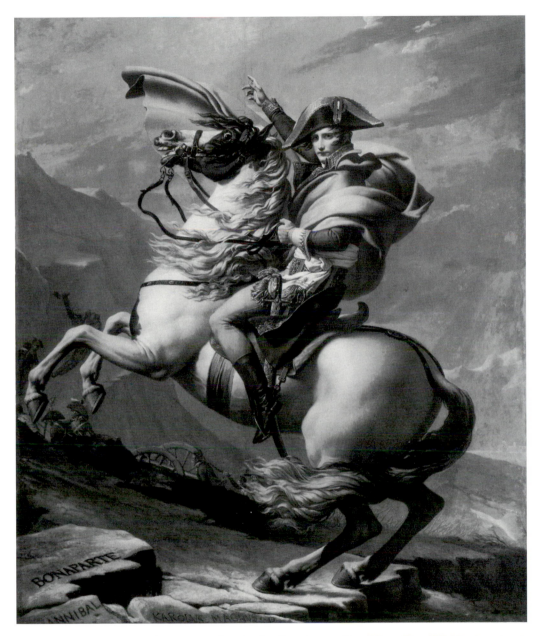

Fig. 14. Jacques-Louis David, *Bonaparte Crossing the Alps*, 1800–01 [Republican Year IX]. Musée national des Châteaux de Malmaison et de Bois-Préau, Reuil-Malmaison. Photo: RMN

COOPER PENROSE

Portrait of Cooper Penrose by Jacques-Louis David, which bears the date of the Republican Year X (1801–2), was acquired in 1953 by the Putnam Foundation for the Timken Museum of Art (pl. 2). It became familiar to a wide audience only after it appeared as a full-page color reproduction in Antoine Schnapper's 1980 monograph on the painter.[23] Probably because the painting was not included in the comprehensive retrospective of David's paintings and drawings organized in Paris in 1989, it has not received much commentary, nor has the sitter's biography been much explored. Richard Rand's entry in the 1996 catalogue of the Putnam Foundation Collection constitutes the most persuasive attempt to document and interpret the painting. As Schnapper and Rand have noted, it stands out in David's oeuvre by virtue of its muted colors and the general austerity of its representation. It could not be more different from the bravura conception and the sweeping effect of the contemporary equestrian portrait of Bonaparte. With respect to *Henriette de Verninac*, painted three years earlier, David has visibly modified his manner. Before considering the range of contemporary portrait modes relevant to this evolution, it is first necessary to elucidate the conditions of the meeting between painter and sitter.

It was certainly Cooper Penrose who sought out David.[24] Ever since Stanislas Potowski had commissioned a grand equestrian portrait from David in 1780 when he was a *pensionnaire* of the French Academy in Rome, wealthy foreign amateurs had manifested an interest in his art. In turn, David exploited his international reputation to assert his preeminence in the Parisian art world. The two portraits of the Dutch diplomats in 1795 and the commission from the king of Spain in 1800 well served this end. During the Peace of Amiens (March 25, 1802–May 12, 1803), foreigners poured into Paris to see for themselves how France had changed since the Revolution. For those interested in the arts who came to appraise the modern French school and admire a museum brimming with the spoils of war, David was naturally a recurrent subject of conversation. A visit to the exhibition of *The Sabines,* to which two versions of Bonaparte's portrait were added in September 1801, was an essential part of the Paris experience. More determined visitors would also go to his studio in the Louvre to see some of the earlier paintings for which he was famous.

Details of Cooper Penrose's biography may help to explain why in 1802, although residing in faraway Cork, he decided to join the flow of British travelers going to Paris, "the city of the sciences and the arts, the new Athens."[25] Born into a Quaker family in Waterford, Ireland, on April 10, 1736, Penrose lost his father at an early age and was brought up by his uncle, who worked in the timber trade and who later took him on as an associate in his hometown. In 1763 Penrose wed Elizabeth Dennis, the only child of another prosperous wood merchant from Cork. When his father-in-law and business partner died in 1773, he inherited the Dennis family estate, Woodhill, about a mile from the city center, overlooking the River Lee. The house had been bought in 1749, and a series of adjacent plots were acquired successively, by 1773 constituting a forty-acre estate. Keeping the old house for the servants' quarters, Penrose began construction of a new house the following year. He is reported to have spent two thousand guineas for the mansion, which was completed about 1780 and decorated in the Adam style. Woodhill remained his home until his death on February 25, 1815. He is known to have commissioned family portraits from the local painters Robert Hunter (active 1752–1803) and Thomas Stewart (1766–1801) and to have collected porcelain.[26]

In 1810 the local guidebook, *A Directory and Picture of Cork and its Environs,* devoted several pages to the house. The author begins his description of "the seat of Cooper Penrose" with a bold comparison: "what we should in justice be inclined to name the IRISH VATICAN." It is described as a "neat handsome, modern building, with an elegant wing at each end." The same qualities are attributed to the interior: "The hall was not ornamented with the pride of the chisel nor the pomp of heraldry—everything was elegantly simple—neatness had thrown her grey mantle over its walls, which were indeed again decorated, but it was with the living canvas, that informed me in some appropriate paintings, that taste, and some eminent masters reigned within." Penrose's painting collection is evoked in similar terms: "Being conducted through a neat middle apartment, I entered an elegant saloon

and picture gallery; a pleasing awe pervaded my mind on beholding those immortal artists, RAPHAEL, REUBENS, WYNEX and others, who live in their works. . . . Mr. Penrose has so choice and valuable a collection that it would take a volume to describe them." The enthusiastic visitor also remarks on the architecture of the gallery, "taking up one of the wings of the mansion, and admirably laid out with a dome and lights, which are admitted from the top to great advantage." A final comment in the guidebook seems to refer to Penrose's trip to Paris in 1802: "In addition to this, Mr. Penrose has erected five different apartments, containing twelve niches and twelve half columns, for the purpose of receiving a variety of busts and models, cast from the most rare productions of the ancient schools of Greece and Rome, from whence they were many centuries back removed to VENICE, but since taken by the French, exhibited in their public galleries, and allowed to be copied. Mr. Penrose has erected these beautiful rooms consisting of one octagon, two circular, two double cube or oblong square, as studies for the artist; and every one of them must remain a lasting monument of this gentleman's munificence; and are entitled to universal gratitude."[27]

Penrose's descendants left Woodhill in 1894 and sold the house about 1930 to an art dealer, who dismantled some of the furnishings. The remaining structure was leveled in the 1990s, although photographic records of the exterior and interior are known to exist. The art collection, including *Portrait of Cooper Penrose* by David, which had been hanging in the drawing room at Woodhill early in the twentieth century, was partially preserved by descendants. In 1947 the family sold off the painting by David and about 1950 donated a major painting by James Barry to a Dublin public collection (see below).[28]

Cooper Penrose's taste for antique statuary and for pictures of the Italian and Flemish schools in no way distinguished him from contemporary British connoisseurs and collectors. The modernity of the new house, conceived with a study area for artists, attests to a civic-minded concern to encourage an appreciation for the arts in his locality. Two other details of his biography further suggest sympathies that color his passion as a collector. Penrose appeared on the public scene in 1788 taking a stand against the slave trade in

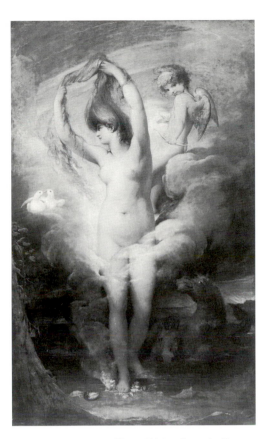

Fig. 15. James Barry, *Venus Rising from the Sea*, ca. 1772. National Gallery of Ireland, Dublin. Reproduction courtesy of the National Gallery of Ireland

the course of a long-term campaign dear to English and Irish Quakers. On January 7, 1788, he proposed to the local Cork Committee of Merchants that a public meeting be called to discuss abolition and to petition the prime minister. After the slave trade was outlawed in Britain in 1807, the Quakers shifted their efforts to promoting abolition in the West Indies. Although there are reports that Penrose was disowned by the Religious Society of Friends for infringing on Quaker discipline, he seems to have continued to support their antislavery initiatives.[29]

The other biographical element that sheds light on Penrose's personality and political sensibility was his ostensible support of James Barry (1741–1806), an Irish compatriot from Cork. At the sale organized after Barry's death by Christie's in London on April 10, 1807, the collector bought the painter's *Venus Rising from the Sea,* an important early work exhibited at the Royal Academy of Arts in 1772 (fig. 15). It seems

most likely that Penrose was attracted by the painter's elevated conception of his art and well-known radical sympathies. His acquisition was made after the obituary in the *Gentleman's Magazine* had unequivocally characterized Barry's politics: "A professed Republican in principle, he felt no concern to disguise his sentiments; he is said, even in public lectures on a Royal foundation, to descant frequently with admiration on the encouragement afforded the fine arts under a Republican compared with a Monarchical government."[30] Contact between the two men is attested by a letter sent to Penrose by Barry on July 13, 1803, and published a few weeks later in the *Monthly Magazine*, in connection with the promotion of prints after his pictures for the Great Room of the London Society of Arts. He ends his missive with a warm exhortation: "Farewell, my dear Sir, and be sure to remember me kindly to your good family, and to all friends."[31] This was a time when Barry was reflecting on a revision of his suite of paintings in order to integrate allusions to recent historical and political developments. He notably attempted to gain permission from the Society of Arts to insert an allegorical subject, the Act of Union between Great Britain and Ireland, referring to the project of a legislative union in the aftermath of the Irish Rebellion of 1798. As it turned out, Barry was no more successful than the political initiative he wanted to celebrate.

Penrose and Barry surely met before 1803, and it seems inconceivable that the collector ignored the latter's polemical brochure, *A Letter to the Dilettanti Society,* published in London in 1799. The painter had written it while in open conflict with his fellow Royal Academicians, which led to his expulsion from the institution. To the dismay of his colleagues, Barry readily invoked Jacques-Louis David as the exemplar of artistic excellence under a republican form of government. In the years that followed, when David's friendship with Penrose is attested, Barry was more avid than ever to develop contacts with radical activists.[32]

Since the late 1780s the fame of the "French Raphael" had reached artists and amateurs in the British Isles. In 1802 the painter Joseph Farington noted in his diary that the *Horatii* and *Brutus* were "two large pictures of which I had in England heard much."[33] However, most British remained reserved toward

what one later called David's "brickdust," in other words, the lack of luster in his painting.[34] Barry's praise for the French painter, in fact, addressed more directly his sense of artistic ambition and civic responsibility than his manner. Penrose was surely impressed by David's international renown, but like Barry he was probably even more fascinated by his political reputation. Farington was repeating a commonplace when he wrote of France's foremost painter, "a more violent Republican than himself did not exist during the period of the revolution."[35] After the Terror, David's artistic reputation was not dissociated from his Jacobin sympathies; during the Peace of Amiens, he was something of a local curiosity for visitors to Paris. Although to a lesser extent than during the time of his exile in Brussels, some foreign admirers were even more desirous of meeting the former crony of Robespierre than the famous artist. He was perceived by many visitors as a formidably intimidating figure.[36]

Paris was able to count a considerable number of portrait painters who offered their services. David was generally considered the most expensive, although not necessarily the most fashionable.[37] Judging from the small number of portraits he actually painted during these years, one suspects that Penrose's commission resulted from a certain amount of persuasion on the part of the aspiring sitter. The high price agreed on for the work—two hundred gold louis—was a strong argument at a time when David was reputedly well-off but with a family to provide for.[38] And in all likelihood Penrose clinched the deal by making it clear that he not only admired the painter but also sympathized with his civic ideals.

Two textual sources inform the execution of the portrait. The first is an undated letter from David to the sitter, contracting for the work: "Mr. Penrose can have complete trust in me, I will paint his portrait for him for two hundred gold louis. I will represent him in a manner worthy of both of us. This picture will be a monument that will testify to Ireland the virtues of a good father [*un bon père de famille*] and the talents of the painter who will have rendered them. It will be handled in three payments, namely 50 louis at the start, 50 louis when the picture is roughed in [*ébauché*], and the remaining 100 louis when the work is finished" (see letter facing p. 1).[39]

The price of 200 louis corresponds to 4,800 livres (or, after the adoption of the franc in 1803, to 4,000 francs), a sizable sum given that one contemporary estimated that the going rate in Paris for a portrait was between 50 and 100 louis. Another report credits Gérard with an asking price of 250 louis for a full-length portrait, comparable to David's lesser fee for a knee-length.[40] At the time of Penrose's commission, David's financial pretensions were justified from having demanded and obtained in 1800 from the king of Spain 1,000 louis (24,000 livres) for *Bonaparte Crossing the Alps.*

Despite the dry financial considerations, the tone of the missive is far from simply business-like. The procedure of requesting three installments was a holdover from David's royal commissions. As David imagines the stages of execution while writing his note, the status of the project seems to evolve: only a *portrait* at first, then a *tableau-monument* in homage to the sitter, it becomes on completion an *ouvrage* contributing to the fame of the painter. That he thinks both their reputations will be at stake in the enterprise reinforces the idea of a mutual understanding between the Frenchman and the Irishman. In 1802 David could not fail to represent Ireland to himself as a nation sympathetic to the French Republic and oppressed by Britain. Why he should want to underscore Penrose in the role of a *bon père de famille,* however, is less simple to fathom. At the time, Cooper Penrose and his wife had two sons and two daughters, born between 1766 and 1774; two other sons and a daughter are reported to have died young. The parallel with David's own family is striking, since he also had two sons and two daughters, born between 1783 and 1786. As they were coming of age, he was increasingly preoccupied with their financial situation. Whether he effectively projected his own concerns on his sitter, the spirit of reconciliation inspiring *The Sabines* shows him to have been receptive to the family values being promoted in post-Revolutionary French society.[41]

Most explicitly, the Constitution of the Year III (1795) had proclaimed: "No one is a good citizen, if he is not a good son, good father, good brother, good friend, good husband."[42] Isabey's drawn self-portrait with his family, *La Barque d'Isabey* (Musée du Louvre), interpreted as an allegory of paternal guidance, with the father steering loved ones past dangers on the river of life, had been acclaimed at the Salon of 1798.[43] Jean-Baptiste Greuze (1725–1805), who much earlier had built a reputation by dramatizing the gamut of paternal affections, may also have been at the back of David's mind. The aging painter was not a forgotten figure on the Parisian scene: his studio was among those visited by curious foreigners.[44] By conceiving of Penrose in terms of a *bon père de famille,* David was also reviving the domestic ideal championed by the Jacobins during the Terror. His sitter, a sixty-six-year-old father of four and a good citizen, was an apt candidate for public recognition. In the spirit of the republican festivals *de la vieillesse* organized by the government during the early Directory, David's homage was conceived as a *tableau-monument.* Prints of such events show the scene centered on an aged couple; the two figures appear seated, placed on a makeshift *sedia gestatoria* during the procession or greeting citizens who pay their respects to them.[45] A similar aura of virtue enthroned informs the conception of Penrose's portrait.

Such republican resonances may account for the unusually long inscription that David appended to his signature: "Louis David painted this in Paris in the tenth year of the French Republic."[46] Using a classical conceit he generally reserved for historical compositions may have been a way for David to register that Penrose shared his admiration for ancient Roman republicanism. It may also have been inspired by their mutual interest in antiquities. Penrose's project to purchase plaster copies of the Louvre's antiques while in Paris would have delighted the painter, in whose studio "busts, statues, casts abounded everywhere."[47]

The artist manages to invest the painted image with a republican aura in still another way. Penrose's sober black costume was perhaps dictated by his Quaker culture, but it also defined him as a partisan of an anti-aristocratic simplicity, recalling the official dress of the deputies of the Third Estate during the meeting of the Estates-General in the spring of 1789, which David had planned to honor in the aborted *Oath of the Tennis Court.* Even the unusually vast expanse of empty space above the seated figure (often reduced in reproductions)—a traditional religious metaphor of the dominion of the spiritual over the

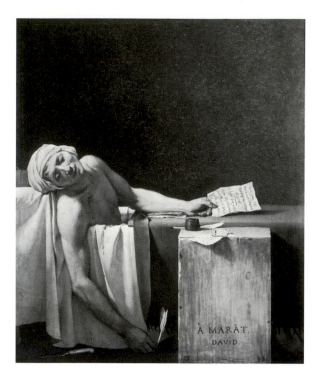

Fig. 16. Jacques-Louis David, *Death of Marat*, 1793. Musée d'Art Ancien, Brussels, Belgium. Photo: Bridgeman-Giraudon / Art Resource, NY

worldly—echoes his radical employment of such a visual effect in 1793 to beatify Marat (fig. 16). The general starkness of the representation, contrasting with the various portrait modes during the Consulate, is ostensibly the result of an aesthetic choice with strong moral resonances. To contemporary eyes, the subdued colors David employed probably evoked the mood of Rembrandt's portraits of the 1630s, as Richard Rand has suggested.

Such sobriety was alien to the conventions of elite portraiture and made some viewers uncomfortable, as is clear from the other source documenting the making of Penrose's portrait, the diary of Joseph Farington, who was in Paris at the time. Like other foreign artists in Paris, he was keenly curious about David. On September 3, 1802, he went with Henry Fuseli and John Opie to view *The Sabines,* which he calls a "Chief work of the French School." Openly unsympathetic with David's method—"I never saw a Composition in which the art of arranging was less concealed"—Farington criticized the picture with easy confidence. A few weeks later, on September 20, this time with a small group including Fuseli and John Hoppner, he

visited "the apartments of David in the Louvre by appointment of Mademoiselle Jaullie, as she is called, a Young Lady from Ireland who is pupil to David." As becomes clear from a later entry in the diary, on October 1, "Mademoiselle Jaullie," or Julia, was Penrose's niece: "We next called upon Mademoiselle Julia as she is called in Paris, at David's, and saw the Half length portrait of Her uncle which was painted by David. She told us He sat Eighteen times for it, from about Ten o'Clock in the forenoon till four in the afternoon. The price was 200 guineas. It was painted in a very poor manner having a sort of woolley appearance as if done in Crayons. It put me much in mind of the pictures of the late N. Hone."[48]

Since he inscribed "an X" on the canvas, it is certain that David had finished the portrait before 1 vendémiaire Year XI (September 23, 1802), the first day of the new year. Allowing for a few interruptions in the sittings, it was probably executed over a period of three weeks, and perhaps longer on account of the concurrent commissions for the First Consul and obligations toward the pupils in the studio who paid for David's guidance. It is a rare insight to be informed of the number of sittings required by the painter; this may explain Juliette Récamier's "impatience" while sitting for her portrait two years earlier. The painter could also be less demanding when necessary, as is apparent from his relations with Bonaparte, who never posed for long, if at all.

That Farington found the forms "woolley," in other words, not sharply defined, may be due to a combination of factors. David avoided the virtuoso finish dear to his younger French rivals, as well as the expressive pictorial effects deriving from Anthony Van Dyck, which the English school had fully naturalized through the work of Reynolds and Thomas Gainsborough. Farington's association of David's portrait with the style of Nathaniel Hone, who had died much earlier, in 1785, is revealing. Hone may have come to mind since, like Penrose, he was Irish. The austere image of the Irish Quaker may have put Farington "much in mind" of the portraits of clergymen, Hone's specialty, many of which were available in mezzotint. He had also achieved notoriety for his painted satire of Reynolds, *The Conjuror,* which had caused a great scandal in London in 1775 and was

probably not totally forgotten a quarter of a century later.[49] By pitting David in the role of the modest Hone, who had taunted the most eminent representative of the contemporary English school, the diarist's association is clearly meant to be derogatory.

In his diary, Farington further notes Fuseli's ironic reaction to Penrose's portrait and the details furnished by his niece: "Fuseli was very merry in his remarks upon the French pictures. He thought David for the eighteen sittings deserved all the money for *day work*, from *such a subject*, which indeed was a very bad one."[50] Manifestly, Penrose struck him as hopelessly uninspiring as a model, and the commission as a result could only prompt a hack job (day work). Fuseli's reactions to contemporary French painting were consistently negative and more than often hyperbolic, but his remark does underline a difficulty contemporaries had with David's understated mode of execution. Another Englishman, Bertie Greatheed, shared this attitude. He also proved himself an acerbic critic of contemporary French painting, notably comparing David's *Bonaparte Crossing the Alps* with William Hogarth's bombastic portrait of Baron Squanderfield on the wall in the first scene of *Mariage à la Mode*. On visiting "David's painting room in the Louvre" in early January 1803, he jotted down having seen "a portrait of a man sitting in an elbow chair; the most hard, villainous thing I ever saw," in all likelihood a reference to Penrose's portrait, which was still with David in May of that year.[51]

On the Parisian stage, at concerts, and on the walls of the Salon during these years, spectators thirsted for heightened visual drama. The public reserved its applause for what one German visitor called "contrasts," reviving a term that had been central to rococo aesthetics.[52] Increasingly, it was expected that portraitists stage their subject in some way. This could mean inventing a novel pose: the life-size portrait of the medal engraver Bertrand Andrieu ice-skating by Pierre-Maximilien Delafontaine (1774–1860), a David pupil, exhibited at the Salon of 1798 as if to outdo Gérard's *Isabey*, is a prime example of this phenomenon.[53] The theatrics could also apply to the execution. This meant deploying bravura handling, whether in terms of what Farington called "high finishing"[54] dear to the contemporary French school or broad effects

characteristic of the English school. David's manner and conception were equally distanced from these two poles, each of which claimed to represent a distinct form of modernity. Whereas Fuseli and other British artists found his portrait of Penrose dull, it is likely, as already suggested, that Gérard, Isabey, and their crowd were more inclined to consider its restraint old-fashioned.

Exactly one month after the visit during which they looked at Penrose's portrait, Farington and Fuseli once again called on "Madamselle Julia" at David's studio on October 3, 1802, this time with J. M. W. Turner and John James Halls. On their way down the stairs of the Louvre, the group passed the painter, who seemed "shy, keeping himself close to one side of the stair case."[55] However, no further mention of the portrait of Julia's uncle appears in Farington's diary, only the note that the young woman accompanied the group a few days later to visit Guérin in his studio.[56] Worth quoting is a later reference to the young woman in another source, confirming her study with David in Paris. Barry, in the postscript to the letter to Penrose on July 13, 1803, cited above, indicated: "Miss Jouille, from the School of David, has called on me. I am much pleased with some portraits she has begun. The heads, the only finished parts, are admirable. If she will labour, she is calculated to do honor to her master, and to everyone concerned about her. I should be happy to see an Irish Angelica [Kauffmann], who might be able to give lustre to some of those empty spaces in the churches, town-halls, and other public buildings, which have been, if not brutally, yet at least giddily, unthinkingly, unfeelingly, and perhaps foolishly, withheld from me."[57] These comments are of interest concerning the procedure of painting in the head first, which David taught and practiced, as his unfinished portraits demonstrate. They also further confirm Barry's admiration for the French painter.

That in his scrupulously detailed journal Farington makes no mention of direct contact with Penrose, either in the course of his daily outings in the company of British artists and amateurs or at social gatherings organized for foreigners in Paris, suggests that the Irishman probably kept mostly to himself during his stay. Such a spirit of independence with regard to the diversions of Parisian society, a trait shared by David,

as has been noted, was likely to reinforce the mutual sympathy existing between the two men. As best exemplified by *Penrose* in 1802 and later by the smaller *Turenne* in 1816 (Clark Art Institute, Williamstown, Massachusetts) and by *Sieyès* in 1817 (Fogg Art Museum, Cambridge, Massachusetts), it seems that when David was able to identify with his sitters, with their experience, situation, values, or aspirations, he managed to overcome a past that haunted him and attain a kind of happiness and serenity.

PORTRAIT MODES AND CODES DURING THE CONSULATE

The art created during the Consulate—from 1799 to 1804—tends to be constructed as the survival of a past and the intimation of a future than as a complex historical present: as an inflection of neoclassical conceptions dating from the 1770s and 1780s and as a premonition of Romantic expressions fully maturing only in the 1810s and 1820s. In the first instance, it is mined for a sentiment of fidelity to republican ideals; in the latter, for the emergence of an affirmed individualism and the premises of the personality cult that were to characterize the Empire. It might be more illuminating to narrow the frame and consider both synchronic interactions during the period and continuities with the Directory, the preceding period with which it has much in common.

Following the dissolution of the Ancien Régime system of the arts and then the demise of the interventionist Jacobin government, artists were completely on their own, largely unhampered by official pressure, free to succeed or to change profession. They could adopt whatever strategy might catch the attention of the public. The novel spectacle of revision, experimentation, and gesticulation resulting from this post-Revolutionary reordering survived into the Consulate. The reconstructive mood endured, and artistic production was boosted by a notable rise in private and public commissions, the latter granted at first somewhat haphazardly. Parisian studios had not been so busy in more than a decade, and an artistic career never appeared so attractive to young people. On arriving in the capital in the autumn of 1799, the young provincial

Henri Beyle, later to become famous as Stendhal, adopted Guérin as a role model and was thrilled to join the studio of his master, Regnault. The new climate of confidence in the arts incited a great number of unknown painters, draftsmen, and miniaturists to try their chance at the Salon for the first time, and among their ranks women were in greater proportion than ever before, and perhaps ever after.

As Tony Halliday has demonstrated so well, in the absence of a private market for history painting during the Directory, painters and critics made concerted efforts to raise the status of portraiture as a genre, in other words, to convince the public that the best portraits should be regarded as works of art and not simply as likenesses. Traditionally, it was affirmed that mastery in history painting accounted for excellence in portraiture. About 1750 this notion had been used by French critics as part of a move dedicated to regenerating the arts. In the dictionary he compiled with Henri Watelet in the 1780s, Pierre-Charles Lévesque develops this position, insisting that in ancient Greece, the best portraits were painted by Apelles, the most famous of Greek history painters. He surmises that so long as the two genres shared a "même manière"—when Raphael, Titian, and Veronese were alive—portraiture was imbued with a sense of grandeur. The advent of specialist artists concentrating on description and detail, who emerged when *maniera* led history painters away from nature, resulted in a profound degradation of the genre. Lévesque concludes his entry on the portrait, clearly inspired by his reading of Reynolds, with a lyrical outburst: "Thus all is ideal, all is magic in art. It allows falsehood to penetrate even its most precise expressions of the truth; it fascinates the eyes of spectators, and in order to provide them with the representation of an object, it employs an even greater prestige than truthful imitation. Since the portrait is in itself a lie, it will never be better treated than by that artist who from working in the historical genre has become familiar with the great falsities of art."[58] At the Salon of 1801 the conservative critic Jean-Baptiste Boutard attempted to reverse this traditional position and champion portraiture over history painting, foregrounding an odd mix of market values and social nostalgia at the expense of high-blown aspirations with too republican a taint. By 1804, however,

as the perspective of an imperial regime with clear ambitions for the arts modified the situation, he had become less bold and professed the commonplace notion that a training in history painting best prepared an artist for the task of portraiture.[59]

The format adopted by David for *Penrose,* a knee-length seated figure, has a long history. Raphael's portraits of *Julius II* (ca. 1512, The National Gallery, London) and *Leo X with His Two Nephews* (1518, Uffizi, Florence), and a number of other sixteenth-century Italian masterpieces had invested this pose with an exceptional authority, capable of preserving an aura of official dignity while more intimately revealing a personality. Often in the course of the sixteenth and seventeenth centuries, pendant portraits of princely and aristocratic couples reserved the seated pose for the woman and the standing pose for the man.[60] But whereas Van Dyck respected this convention in full-length pendants painted in Antwerp, he often represented Flemish couples in betrothal portraits sharing a seat. Likewise in Holland during the seventeenth century, both man and wife generally preferred either to sit or to stand. Nonetheless, as many family portraits from this period confirm, the seated pose could remain associated with the subservient maternal and domestic role attributed to women. During the eighteenth century, as the cult of private and social virtues gained prominence over the traditional aristocratic cult of military valor, the portrait with the sitter engaged in some intellectual or cultural activity, most often writing, reading, and administrating, became a visual code of Enlightenment ideology. The Paris Royal Academy canonized the seated pose and the three-quarter-length format, which was adopted for many of the official portraits of its members.[61]

David began his career by confronting the whole range of possible formats, always life-size, from the close-cropped bust in an oval popular in his youth to the spacious full-length associated with aristocratic magnificence. But about 1790 he concentrated on what might be called his signature knee-length format. That he painted a suite of portraits of this type in close succession denotes that he was particularly satisfied with this conception. He may have liked the firm pyramidal composition, even though he was averse to using this standard academic conceit in his history

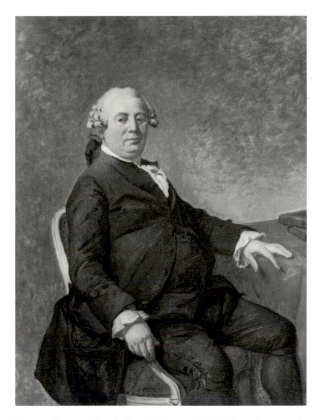

Fig. 17. Jacques-Louis David, *Portrait of Philippe-Laurent de Joubert,* ca. 1789–92. Musée Fabre, Montpellier. Photo: RMN

paintings. The portraits in the suite—two sisters, *Anne-Marie-Louise Thélusson* (1790, Alte Pinakothek, Munich) and *Robertine Tourteau* (1790, Musée du Louvre), *Philippe-Laurent de Joubert* (ca. 1789–92, fig. 17), *Louise Pastoret* (ca. 1791, The Art Institute of Chicago), and *Louise Trudaine* (ca. 1791–92, Musée du Louvre)—have in common a figure framed just below the knees, set against a neutral background, with a reduced number of props, often only a chair or an armchair. David pursued the series with the two *Sériziat* (1795), *Henriette de Vernicac* (1798–99), and *Cooper Penrose* (1802). The inflection given to the type in *Cooper Penrose* is worth underlining: the sense that the sitter aims to charm or impress the viewer, as in the earlier portraits, has vanished; the space around the figure is more extended, more obviously empty and enveloping, and no longer simply a backdrop. The matter-of-fact character of the rendering, alien to the lingering artificiality of late Ancien Régime portraiture, is reinforced by the narrow range of colors. Vigée Le Brun in her portrait of Charles-Alexandre de

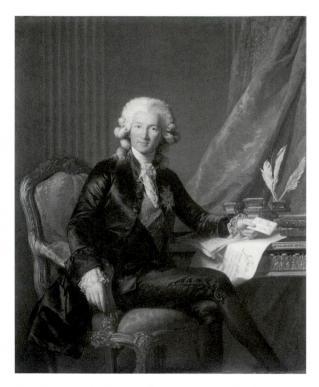

Fig. 18. Elisabeth Vigée Le Brun, *Portrait of Charles-Alexandre de Calonne*, 1784 (Salon of 1785). The Royal Collection. © 2003 Her Majesty Queen Elizabeth II

Calonne in 1784 had shown how black clothes could occasion a show of virtuosity in the play of reflections and infinitely varied details (fig. 18). David reserves this bravura mode, not for the striking harmony of Penrose's black-and-white outfit, but very discreetly for a single detail: the armchair covering, a fabric with alternating matte and shiny black stripes.

With respect to the portraits by David mentioned above, this one is singular on account of the unequivocally dominating stance of the painter toward his sitter. The unusual expanse over Penrose's head effectively creates the impression that David stood and looked down as he painted. Unverifiable family recollections attribute to David a condescending attitude toward the Irishman, which this point of view might seem to articulate, but the stance was probably less social than moral. It was common for a sitter's chair to be placed on a dais: a theatrical mise-en-scène intended to extract the subject from the mundane surroundings of the studio, an elevation both real and metaphoric since a lowered angle of vision conferred

on the sitter a semblance of aristocratic deportment. Viewed from slightly higher than was usual, Penrose appears surprisingly more lifelike than do most seated figures: he is as one might actually come upon him. The unusual framing contributes to this illusion by seeming to exert a downward pull on the figure. The hands also participate in this contrived show of naturalness. While the left hand is at rest and somewhat flaccid, the right is animated as if Penrose were in conversation. Consciously or not, David delves into *chirologia,* the art of manual rhetoric, expounded in the seventeenth and eighteenth centuries through prints, which had proved to be a great help to portraitists at the time. Penrose's alert eyes, raised eyebrows, and wry expression of the mouth suggest that he has just made an interesting quip to which the gesture of his right hand adds weight.

David's social retrenchment and superior reputation did not deter him from observing the strategies and productions of his contemporaries. On the contrary, he was a profoundly reactive artist: able to respond to rapidly changing political circumstances as is well known, but also to trends and innovations that reaped success. Although his receptivity to the archaizing principles and practice of certain of his pupils, the so-called Primitifs or Barbus, has long been admitted and invoked to account for the Hellenizing mood of *The Sabines,* his art has not generally been construed in terms of a close dialogue with the work of contemporaries. Since he built his reputation during the 1780s on direct confrontation with his peers, Peyron, Vincent, and Regnault, it would not be surprising to find him adopting a similar creative strategy during the Directory and Consulate. Open competition among artists was a particularity of this period and came to an end only when secure official positions were meted out by the emperor. Many of the most successful artists— Gérard, Girodet, Gros, Isabey—were former students with whom David had developed an unusually intense relation. As the reading of Gérard's portrait of *Isabey* has stressed, a typical Oedipal reaction is one way to interpret the combination of admiration and defiance they felt toward their master. This was reason enough for David to be wary of their assault on his preeminence, but more generally, as the portraits of Henriette de Verninac and Juliette Récamier demonstrate, to

want to keep up with the times, even if that meant submitting to the vagaries of fashion.

The proposition that David was closely interacting with the work of other artists is supported by the internal dynamics of the Parisian art world in the aftermath of the Terror. That many artists lived and worked within the same urban confines, even within the same building, the Louvre, where the most fortunate were accorded studios and lodgings, helped forge a sense of community. By choosing to be represented by Gérard in 1795 on a stairway landing of the Louvre, Isabey, who resided elsewhere at the time, was making a claim to social prominence best understood by other artists, and, as already suggested, when Boilly painted his studio three years later, it was imagined less a work space than a professional meeting ground. The concentration of artistic activity in the royal palace, which had facilitated contacts among artists and artisans since the time of Henry IV, came to an end in 1801–2, when the installation of the museum became a priority. David alone was able to hold out until the end of 1804.[62] This dispersion was concomitant with a number of other changes imposed on the art world by an increasingly directive Napoleonic administration.

After the dissolution of the academic system in 1793, the affirmation and recognition of artists' social and professional identity became the key to their economic survival. This put the accent on shared culture and practice, as expounded in the many new journals and publications specifically addressing a readership of artists. Although painters like Gérard and Isabey made a point to appear in fashionable society and mingle with their clientele, artists were especially eager to congregate in their studios and around the exhibitions, or at banquets organized in homage to a newcomer or a veteran. Such professional bonding was characterized by an anxiety of belonging and a narcissism of minor differences, which as Sigmund Freud would note a century later, was generative of tensions. The high prices commanded and publicized by certain artists and paid by private and official clients seemed to transform the social fantasy into reality. The publication in 1801 of an entertaining little volume by the Danish amateur Tønnes Christian Bruun Neergaard, *The Situation of the Fine Arts in France,* in large part based on conversations with artists and repeated visits to their studios, further convinced those mentioned of their social importance. Whereas the standard Salon reviews focused on the exhibited works, Bruun Neergaard furnished a lively and attractive picture of the major figures of the milieu at work. The studio rounds made by foreign visitors during the Peace of Amiens, evoked in a stream of books, also favored the play of an internal network, inciting artists to focus their attention on one another. The relative silence surrounding the work of one of the most notable painters of the period, Jean-Baptiste Regnault, confirms that those artists who kept too discreet a professional profile were at a disadvantage and largely ignored. As mentioned, this particular climate of emulation, at the moment when David painted *Penrose,* was to be short-lived. Napoléon and his arts advisor Dominique-Vivant Denon would burst the bubble of artists' financial and social pretensions. Their fantasy would be degraded to that of imperial civil servants.

Invoking a variety of portraits will not simply exemplify the contemporary dialogue between David and other painters. The artistic conceptions alien to David's principles highlight the remarkable and perhaps unsuspected diversity of the practice against which he worked. The paintings brought together for this exhibition serve to expatiate on the two fundamental themes of dialogue and diversity. In his study, Halliday stresses the impact of the political context on portraiture, as suggested by the title of his chapter "Private Art in an Age of Dictatorship," which he illustrates with paintings that might have been shown here: Martin Drolling's *Self-Portrait* (1800, Musée des Beaux-Arts, Orléans), Robert Lefèvre's *Carle Vernet* (1804, Musée du Louvre), and Girodet's *Larrey* (1804, fig. 25). Since neither this exhibition nor this essay can pretend to resurrect all the portraitists who were present at the Salon from 1799 to 1804, the focus is instead on the rich texture of pictorial practice of which David was most likely to be aware when painting *Penrose.* The epithets used by British visitors to depreciate this portrait—"woolley," "most hard, villainous"—are not necessarily representative of dominant opinion, but they raise the question of the expectations of David's contemporary audience. Although canonical art history no doubt will have trouble endorsing the move, the diversity of style provocatively suggests a position for

Fig. 19. Anne-Louis Girodet, *Portrait of Jean-Baptiste Belley*, 1796–97 [Republican Year V] (Salon of 1798). Musée national des Châteaux de Versailles et des Trianons, Versailles. Photo: RMN

David's art on the margins and no longer at the center of art practice during the Consulate.

A fascinating and deeply biased list of portrait painters active in Paris in 1800 is provided by Jean-Baptiste Pierre Le Brun, the dealer-painter husband of Vigée Le Brun, "commissaire expert du Musée central des Arts," who in the aftermath of Brumaire was asked by the minister of the interior, Lucien Bonaparte, to furnish him with a list of the best contemporary artists.[63] The purpose of the list was to allow the minister to distribute commissions best corresponding to the capacities of the recipients. Among the *peintres d'histoire,* Le Brun mentions David, Gérard, Girodet, Prud'hon, and others who were known to practice portraiture as well, but he singles out only five artists under the heading *peintres de portrait:* first his wife, then Greuze, Drolling (1752–1817), Jean-Joseph Eléonore Ansiaux (1764–1840), and Jacques-Luc Barbier-

Walbonne (1769–1860). Le Brun resurrects two figures from the past and promotes three talented younger men whose ambitions were, however, to prove limited.

Bruun Neergaard is both more comprehensive and more perspicacious. He reports an observation made by an unnamed "history painter" deploring that so many untrained individuals were calling themselves artists: "it's gotten to the point where a number of fellows, who can barely hold a pencil, have set themselves up as portrait painters; and Paris is full of persons who have made a preferred choice of this genre, judging it easier." The Danish critic, offering his own view on the subject, underlines "how hard it is to attain that degree of perfection, acquired by so few, except the likes of a Gérard and a Girodet, who studied with the great history painter David." With regard to the portrait practice of these masters, he probably surprised his French contacts by boldly claiming the superiority of his compatriot Jens Juel (1745–1802): "If these artists have some advantages over our Juul [Juel], the latter also has some over them, as a portrait painter. His drapery, especially, is the most beautiful I know." Referring to the works he had seen at the Salon in 1800, and adding that few of the portraits exhibited merited to be singled out, he provides a generous list of artists worthy of attention, headed by Gérard and Girodet, and including several women: Adélaïde Labille-Guiard (1749–1803), Jeanne-Elisabeth Chaudet née Gabiou (1767–1832), and Marie-Guillelmine Benoist (1768–1826), whom he refers to as "*Madame* Laville Leroulx."[64]

The supremacy of history painters as portraitists was eloquently demonstrated at the end of the Directory by Girodet's *Jean-Baptiste Belley* (1796–97, fig. 19) and David's *Henriette de Verninac* (fig. 10), prime examples of what both Le Brun and Bruun Neergaard called purity of style. As already implied with respect to David's painting, the difficulty in implementing such an aesthetic predicated on antique sculpture was the conciliation of the generalized ideal with the expressive and descriptive requisites of the portrait, a dilemma that Girodet, in this instance at least, apparently resolved more successfully than his master.

The question of pictorial finish, exemplified in these two paintings, was a major preoccupation during the post-Revolutionary years. Regnault and Girodet

had shown the way to a smooth manner that concealed brushwork, usually associated with the small-scale art of the seventeenth-century Dutch fine painters (*fijnschilders*), but carried over to a larger scale in the early eighteenth century by Adrian van der Werff and others. Denis Diderot on occasion railed against what he called "léché," a cold and insipid overworking giving the unpleasant sensation that painting was toilsome. By David's time, such technical proficiency had suffered much criticism, although this did not prevent Boilly's paintings and Isabey's drawings in this vein from being extremely popular with the Salon public. In the historical genre, the success of Gérard's *Cupid and Pyche* (1798, Musée du Louvre) and David's *Sabines* (1799) focused attention on polished execution, which gained authority within the context of the museum's unequivocal homage to sixteenth-century Italian painting. Such contemporary obsessions with beautiful finish also found legitimation through the invocation of the antique. Although predicated on sculpture, the aesthetic of the *beau idéal* found a corresponding pictorial expression in the advocation of a linear style, promoted by the serial publication of a French edition of John Flaxman's illustrations to Homer in 1802 and 1803. And yet no painter could ignore the fact that many critics were unhappy with the "dry and cold productions" of this "new method."[65]

The criticism addressed to Girodet in 1800 by David's ally Pierre Chaussard, objecting to the laborious manner of his *Jean-François de Bourgeon* (fig. 20), attests to the radicalization of pictorial practices under the combined pressure of the market and the museum: "I have only one reproach concerning this artist, which is to have painted this portrait with so much art and realism [*vérité*] that it appears to have cost him a great deal of time. What he has lost polishing a suit of clothes could have been employed to polish a masterpiece of history painting."[66] The remark is particularly caustic. Since the Renaissance, painters had made a point to conceal the traces of their labor to distinguish themselves from lowly artisans. With the analogy between the paintbrush and the clothes brush, the David camp hits a bull's-eye. Paradoxically, Chaussard implied, Girodet's obsessive quest for perfection in rendering the surface quality of objects downgraded his portrait to the mundane level of descriptive genre

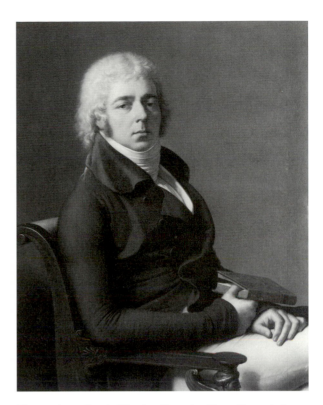

Fig. 20. Anne-Louis Girodet, *Portrait of Jean-François de Bourgeon* (Salon of 1800). Musée de l'hôtel Sandelin, Saint-Omer. Photo: RMN

and trompe l'oeil. In spite of its life-size scale and its generalized setting, his painting elicited a troubling rapprochement with portraiture in the Dutch tradition, proposed at the time by Boilly (fig. 32) and Adèle Romany (1769–1846; pl. 9). The conception of Girodet's *Portrait of M. Trioson, Doctor of Medicine, Giving a Geography Lesson to His Son* (1803, fig. 21), affirms even more explicitly a preoccupation with illusionistic effects: the fly on the globe is a distinctive detail borrowed from Northern still life.[67] Even in a rather straightforward bust of a woman dressed *à l'antique* painted in 1804 (pl. 6), Girodet introduced a quirky detail that subverts the classical ideal David had perfectly engineered in *Henriette Verninac*: the asymmetrical treatment of the eyes, perhaps suggestive of the sitter's strabismus, which annuls the first impression of statuesque harmony and shatters the viewer's expectations. Critics found such aesthetic hybridization even more threatening than the prospect of an absence of hierarchy among the different genres, since collectors and the market had endorsed such an egalitarian

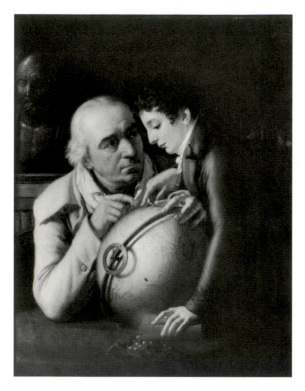

Fig. 21. Anne-Louis Girodet, *Portrait of M. Trioson, Doctor of Medicine, Giving a Geography Lesson to His Son*, 1803. Private collection

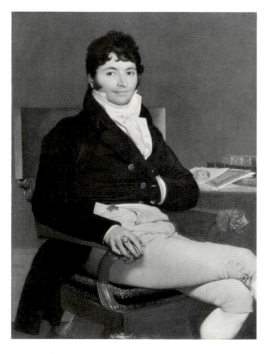

Fig. 22. Jean-Auguste-Dominique Ingres, *Portrait of Philibert Rivière*, 1804–5 [Republican Year XIII]. Musée du Louvre, Paris. Photo: RMN–Gérard Blot

principle for more than a generation.[68] This may explain why David, as time went on, would readily commend Boilly, whose accomplishments respected the boundaries of his chosen genre, while he expressed reservations concerning Girodet, whose art confounded him.

After painting *Henriette de Verninac,* David backed off from a nacreous manner requiring the sacrifice of his signature *frottis.* He was perhaps appalled by Girodet's idiosyncratic course and surely came to see this as a misguided direction. The portraits by Jean-Auguste-Dominique Ingres (1780–1867), one of his pupils who had helped him paint *Juliette Récamier,* would soon confirm these apprehensions. In his *Portrait of Philibert Rivière* of 1804–5 (fig. 22), Ingres replicated David's conception of a seated figure in a knee-length format, but the result was a hallucinatory vision of frighteningly hard matter. David's reaction was probably that of the critics at the Salon of 1806, who interpreted the visual precision of the newcomer's style as a disturbingly regressive move: indifferently caressing every element in the picture, it was a negation of the traditional primacy of the figure over the accessories. Considering the usual discretion of his own props, David surely found the massive armchair in Rivière's portrait somewhat monstrous. During the 1780s criticism of the paraphernalia of fashion in portraiture had adopted an overtly moral tone, but times had changed, and in 1804 the conservative journalist Boutard, hoping to counter the durable fascination for a Revolutionary austerity legitimized by the antique, declared that the depiction of costume, furniture, and diverse objects contributed to the interest of a portrait and furnished an occasion for painters to prove their excellence.[69]

As for Antoine-Jean Gros, who had remained in Italy during the Directory and developed a warm colorist technique inspired by the Venetian school and Rubens, he momentarily surrendered to the vogue for high finish: ostensibly with *Sappho,* exhibited at the Salon in 1801, and more subtly in the posthumous portrait of Christine Boyer, painted after her death in the spring of 1800 (fig. 23). But after these concessions, he quickly returned to his freer brushwork, which had proven its efficacy servicing Bonaparte's destiny and which animates a family portrait of a boy painted in

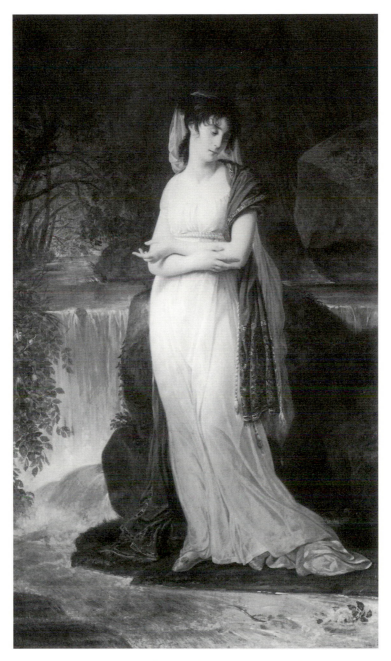

Fig. 23. Antoine-Jean Gros, *Portrait of Christine Boyer*, ca. 1800.
Musée du Louvre, Paris. Photo: RMN

1804 (pl. 7), whose mannered sweetness comes straight from Greuze and Vigée Le Brun.

Compared with *Penrose,* David's *Pierre Sériziat* sits uneasily and *Henriette de Verninac* looks petrified. In the 1804 *Suzanne Le Peletier de Saint-Fargeau* (pl. 3), although only a half-length, the artist aims to infuse the naturalness of Penrose with a heightened sense of monumentality: the frontality of the pose suffers almost no inflection. Gérard had felt it necessary to give a slight turn to the shoulders of his unusually direct bust of Bonaparte, precisely dated February 1803 (fig. 24), a painting that had surely caught David's attention at a time when both artists were competing for official favor.[70]

Despite the severity of the pose, the figure of Suzanne Le Peletier seems warm and alive. David renders homage to her regular features and gives her a pensive, almost melancholic expression. Such reserve contrasts with the elaborate treatment of the unmistakably fashionable attire and tousled hair. Nothing is known of David's relation to the sitter. Although she was the daughter of the assassinated deputy Le Peletier de Saint-Fargeau, whose deathbed portrait he had

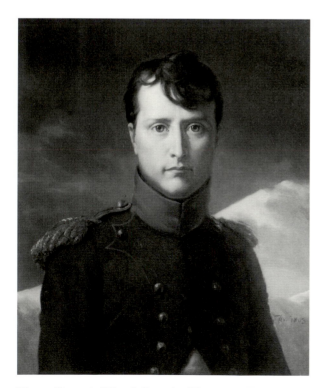

Fig. 24. François Gérard, *Portrait of Bonaparte, First Consul,* 1803. Musée Condé, Chantilly. Photo: RMN–Harry Brejat

painted in 1793, indications are that the commission was, in essence, a society portrait. One suspects that David wanted to compete with the format and subdued mood characterizing the portraits by the great masters of the Renaissance hanging in the newly christened Musée Napoléon. A similar exercise in monumentality is Girodet's *Dominique Larrey,* exhibited in 1804 (fig. 25). Although like Gérard he does not dare place the shoulders absolutely parallel to the picture plane, the sense of immobility, the stern expression, and the cropped format imbue the image with the force of a sculpted bust. A portrait by a painter of the same generation, Guillaume Guillon-Lethière (1760–1832), dating from the late Directory or early Consulate, representing an unidentified young woman artist (fig. 26), underlines the classicizing conception adhered to by David, Gérard, and Girodet at the time. Like her slicked-down curls, her tight-waisted figure seems curiously mannered by comparison, almost a *figura serpentina.*[71]

Gérard's virtuosity and versatility as a portraitist were at their height during the Consulate. In a similarly restrained mode as the *Bonaparte* of 1803, he had painted a full-length portrait of General J. Victor Moreau, which caused a sensation at the Salon of 1800.[72] In a quite different spirit, probably wanting to compete with Girodet's mastery of textural effects, two years later at the Salon he proposed the callipygian vision of an extravagantly dressed Joachim Murat with an oriental boy in attendance. No less ostentatious was the portrait he executed in 1801 of Josephine languorously spread out on a low, cushioned wraparound sofa, a painting that provoked Bruun Neergaard's perplexity when he saw it in progress: "The working manner of this artist is so varied in this picture that one will be at a loss to know to whom it should be attributed."[73] The critic probably refers here to the particularly strong echoes of David's *Juliette Récamier* and Gros's *Christine Boyer* present in the picture. His insistence on the primacy of pictorial unity is familiar enough, but that on the need to be able to identify an artist's "manière de faire"—a transitional expression on the way to the definitive adoption of the notion of style—points to new preoccupations having to do with the art market, for which attribution was a preliminary to appreciation.

With respect to David's paintings, the greater smoothness and fluidity of Gérard's brush inevitably betray his personal manner. Like his master, he tended to adapt his brush to his subject. Although in his portraits of women, finish signifies elegance and perfection, in his private male portraits, such as *Simon Chenard* (1797, Musée des Beaux-Arts, Auxerre), *Antonio Canova* (1803, Musée du Louvre), and *Joachim Le Breton* (1803, pl. 5), a relatively looser brush communicates a more informal sense of control. The cross-armed pose adopted in the last work, shunned by the ancients and distinctively modern in tone, enjoyed a sustained vogue during this period. A particularly fine earlier example is the portrait of the actor Dublin exhibited by Labille-Guiard in 1799 (fig. 27).[74]

Not all ambitious painters fell under the spell of a fascination with finish. In particular, one of the contenders for recognition as the most fashionable painter of the day during the Consulate, Pierre-Paul Prud'hon, seems to have been totally uninterested. His sudden popularity probably came as a surprise to other artists, since this discreet figure of the Parisian art world, although in his early forties, had yet to make a strong showing at the Salon. His oeuvre included several painted allegories in a sentimental mode reminiscent of Greuze and Angelica Kauffmann, a foreign artist whose engraved compositions had pleased the Parisian public since the 1780s.[75] But Prud'hon was known especially for small, preciously finished drawings, which editors in the luxury book trade like Pierre Didot bought up and had engraved. He was often perfunctory as a portraitist but surpassed himself in 1796 with depictions of Georges Anthony (fig. 28) and his wife, Louise Demandre, represented with their two children (fig. 29). Although established in Burgundy at the time of the Salon of 1795, Prud'hon maintained numerous contacts in Paris and may have made brief trips to the capital. It is tempting to view these two portraits as a response and critique of David's Sériziat couple: Anthony, although a rural postmaster, cultivates a sartorial elegance but seems infinitely more natural and confident than Pierre Sériziat, while his wife, shown embracing her younger child, offers an image of affection that morally condemns Emilie Sériziat's posing and flirtatiousness. Proceeding with his usual discretion, Prud'hon did not send these

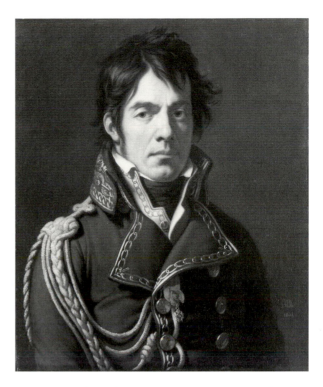

Fig. 25. Anne-Louis Girodet, *Portrait of Dominique Larrey*, 1804 (Salon of 1804). Musée du Louvre, Paris. Photo: RMN–le mage

paintings to the Salon. Yet in the late 1790s he literally burst onto the Parisian scene. He made an uneasy appearance in the background of Boilly's *Reunion of Artists in Isabey's Studio* in 1798 (fig. 2) and began work on a huge allegory for the government, one of the largest paintings exhibited in 1799. Centered on the female nude, like Regnault's *Three Graces* on show that year, the allegory was a programmatic rebuttal of the focus on the male nude promoted by David and his pupils.[76] Lodgings in the Louvre and an invitation to participate in the decoration of the museum were also sure signs of success. The artist's suave black chalk drawings on blue paper were the rage with collectors, according to Bruun Neergaard, who described in detail Prud'hon's stunning decorations for the *hôtel* of a nouveau riche financier. The 1801 publication of the Danish critic's book, with a frontispiece engraved after one of Prud'hon's compositions and a whole section devoted to his work, was the consecration of the artist's claim for celebrity.[77]

"He is the painter of the Graces; some even call him the French Correggio."[78] Bruun Neergaard's opening

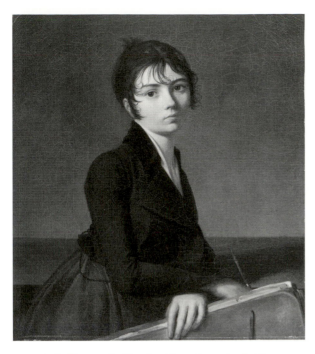

Fig. 26. Guillaume Guillon-Lethière, *Portrait of a Young Woman with a Portfolio*, ca. 1798–1800. © Worcester Art Museum, Worcester, Massachusetts. Photo: museum

Fig. 27. Adélaïde Labille-Guiard, *Portrait of the Actor Tournelle called Dublin* (Salon of 1799). Courtesy of the Fogg Art Museum, Harvard University Art Museums, Bequest of Grenville L. Winthrop

characterization of Prud'hon well qualifies a pictorial style presenting a general softness, attenuated contours, subdued colors, and deep chiaroscuro, and inspired by a sense of the ideal and a quest for harmony. The self-assurance stimulated by the praise and publicity he was receiving is evident in the monumental portrait of the representative of the Batavian Republic in Paris, *Rutger Jan van Schimmelpenninck and His Family* (fig. 30), presented at the Salon of 1802. The domestic scene, painted in a palette of browns and greens, is freed of the descriptive constraints of the genre and imagined as a modern Virgilian eclogue. Relinquishing the usual role of standing protector and provider, the *bon père de famille* sits in admiration of his daughter, while his wife stands like a muse with her hand placed affectionately on his shoulder. David may have been receptive to Prud'hon's painting hung on the walls of the Salon, perhaps not to the moody classical vision so distant from the frankness of the confrontation with his own sitters, but to the absence of social affectation and the extolling paternal contentment. The painters who portrayed Schimmelpenninck and Penrose seek to express a sentiment of happiness only familial affection can produce.

The artist most closely associated with Prud'hon is his student and close collaborator Constance Mayer (1775–1821), who also shared his domestic life for almost twenty years. She was drawn to Prud'hon, it seems, only in 1803, after exhibiting regularly at the Salon since 1796 and presenting herself in 1801 as an "élève des citoyens Suvée et Greuze." The influence of these two is quite strong in the grand double portrait of herself with her father pointing to a bust of Raphael, an audacious statement of her personal ambitions as an artist sent to the Salon that year (pl. 8). The influence of Suvée's classicizing manner pared down almost to dryness is apparent in her own graceful but inert figure, while the softness of contour—Farington might have said the "woolliness"—of the paternal image is unmistakably an imitation of Greuze's late manner. It seems natural that she was subsequently attracted to Prud'hon, who in a sense synthesizes and elevates these two styles. No less important in Mayer's double portrait is the attempt to define for the scene a convincing spatial setting. The indecisive clutter and confusion, which on this scale cannot dissimulate some

perspectival ambiguity, suggests that she worked less with history painting in mind than with the Northern tradition of small-scale interiors and portraits, a descriptive aesthetic that under Prud'hon's influence she would soon abandon.

Mayer's submissions to the Salon were part of a momentous offensive on the part of women artists during this period to present their work to the public. This was both a quantitative and a qualitative phenomenon. Halliday exhumes mention of an event highlighting the place of women in the art world at the time. In the fall of 1799, about two weeks after the banquet organized by the male artistic community in honor of Guérin, thirty women painters gathered in a fashionable restaurant to pay their homage to the hero of the Salon that year.[79] This inspired some sarcasm in the press, but certain critics took the phenomenon and its implications seriously. Through 1804 discussion went on as to how the cause and promotion of women artists might be best served.[80]

For talented women to become actively participating artists it was necessary that academic control over the Salon had to end, but that was not sufficient. How this phenomenon came about is not perfectly clear, since no organized effort was made to encourage and facilitate their training. It is often argued that the 1792–93 backlash against the intervention of women in public politics rendered their pursuit of professional ambitions more difficult than ever. As David seems to have intuitively understood by choosing to paint *The Sabines,* after Thermidor women were better prepared than men to take initiatives in favor of social reconstruction and reconciliation.[81] Manifest was the extraordinary will to achieve recognition on the part of women artists, who seized every available occasion to progress, in particular through the informal lessons offered by some of the major painters and the mutual encouragement of female bonding. If this development was possible, it was also because no official policy opposed it. The hostility of certain critics in the press, well documented by Halliday, and complete exclusion from membership in the Institut national and participation in the Rome Prize contests failed to crush women's determination. It would take the reorganization of the arts and domestic life at the advent of the Empire—the system of commissions instigated by

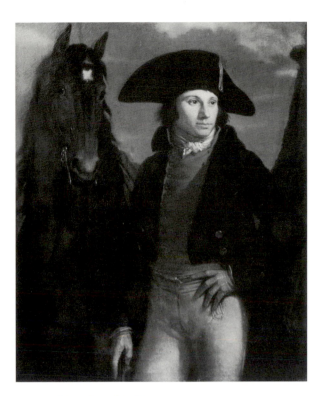

Fig. 28. Pierre-Paul Prud'hon, *Portrait of Georges Anthony*, 1796. Musée des Beaux-Arts, Dijon. Photo: museum

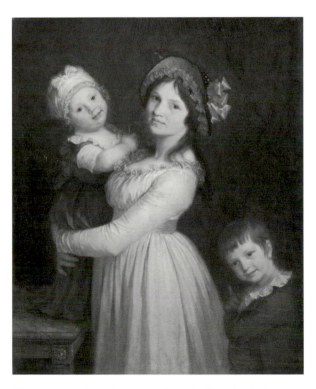

Fig. 29. Pierre-Paul Prud'hon, *Portrait of Louise Anthony née Demandre and Her Children*, 1796. Musée des Beaux-Arts, Lyons. Photo: RMN–R. G. Ojeda

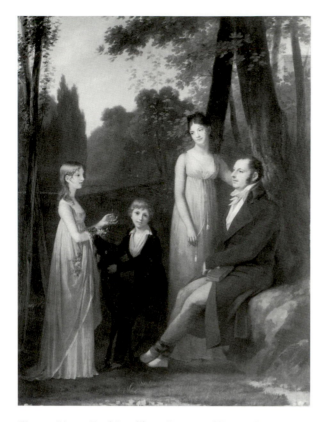

Fig. 30. Pierre-Paul Prud'hon, *Portrait of Rutger Jan van Schimmelpenninck and His Family* (Salon of 1802). Rijksmuseum, Amsterdam

Dominique-Vivant Denon and the bourgeois Civil Code imposed by Napoléon—to reduce the movement. And yet during the Empire, two women painters who had shone during the Directory and Consulate—Marie-Guillelmine Benoist and Césarine Davin-Mirvault (1773–1844)—received important official commissions like their male counterparts, and under the aegis of David, Angélique Mongez (1775–1855) pursued an impressive career as a history painter, beginning in 1802.[82]

Bruun Neergaard acknowledged the presence of women in the art world but was rather dismissive: "Many women, to be in fashion, practice painting, or attend certain lectures in natural history, but in the lot there are only six or seven that merit distinction."[83] He then instinctively referred to Vigée Le Brun, mentioning simply that she had not yet returned from emigration; along with Labille-Guiard, she was generally credited for having shown the way to a new generation. The fall of the Ancien Régime had opened career

possibilities that were much more varied than ever before. At least one woman, Marguerite-Julie Charpentier (1770–1845), gained recognition as a sculptor. She sent busts regularly to the Consulate Salons and during the Empire collaborated on the Column of the Grand Army for the Place Vendôme. Genre painting, sometimes on the scale of life, was practiced and in a sense redefined by women, notably Constance Charpentier née Blondelu (1767–1849), Jeanne-Elisabeth Chaudet, and Adèle Romany. The first exhibited a refined allegory of Melancholy at the Salon of 1801, boldly inviting comparison with a painting of the same subject presented by Vincent.[84] In their anecdotal compositions, the other two developed a singular classicizing mode by integrating the formal qualities of history painting.

In the realm of portraiture, both men and women artists were at times prompted to paint on a small scale and situate their figures in precisely detailed interiors. About 1800 some were perhaps not indifferent to the fact that members of Bonaparte's family were patronizing Jacques Sablet (1749–1803; fig. 31), who had begun specializing in this type of portrait in the early 1780s.[85] Boilly had contributed to the vogue by redefining the Dutch genre appreciated by rich collectors as a popular contemporary mode (fig. 32). His interest in optical play, as evidenced in his paintings of trompe l'oeil, unfailingly provoked discussion when exhibited at the Salon; presented as a reasoned preoccupation with pictorial illusion, these works tended to dignify the concern for realistic depiction.[86] The image of the poet Louis Vigée shown at the Salon of 1800 by Romany revives the saturated ambience of eighteenth-century society portraiture (pl. 9), but on a scale that draws attention to the exquisite rendering of costume and furniture. The spectator is invited to relish a visual and pictorial tour de force. The small scale means that the viewer is not overwhelmed by the wealth of accessories attesting to the sitter's social status; unassailed by a life-size bodily presence, the viewer embraces the microcosm of the private surroundings with a sense of empathy. Vigée was known to recite his verses at fashionable social evenings, yet he chose to appear, not in a theatrical élan of inspiration, but in a moment of carefully posed intimacy. Lévesque had succinctly attempted to theorize the vogue for

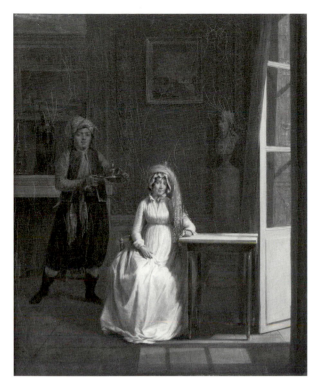

Fig. 31. Jacques Sablet, *Portrait of Letizia Bonaparte*, ca. 1799–1801. Musée Fesch, Ajaccio. Photo: RMN– Gérard Blot

Fig. 32. Louis-Léopold Boilly, *Portrait of François-Adrien Boildieu* (Salon of 1800). Musée des Beaux-Arts, Rouen. Photo: © Musée des Beaux-Arts de Rouen. Didier Tragin/ Catherine Lancien

portraiture on this reduced scale when he noted in the mid-1780s: "One finds this same naïveté of nature in the portraits painted in England over the last few years. It's on account of this realism [*vérité*] that family pictures produced in this Nation have an attraction which is touching."[87] These were strong words for all those who championed the celebration of domestic values and private emotions. Even painters working on a grand scale found the idea of a portrait in an interior attractive. Gérard in particular seems to have grasped the modernity of this mode. Although the setting of the group portrait of the goldsmith Henri Auguste and his family shown at the Salon of 1798 is still rather conventional and generalized, for the *Comtesse de Morel-Vindé and Her Daughter* exhibited the following year, he ostensibly situated the two women in their Parisian home (fig. 33).[88]

The most ambitious female portraitists during the Consulate were without a doubt Marie-Guillelmine Benoist and Césarine Davin-Mirvault. The portraits they produced about 1800 contradicted the position,

taken notably by the painter-critic Charles-Paul Landon, that since propriety prevented women from being trained in history painting, their manner of painting was necessarily different from that of men. Even when it came to portraiture, it was considered that not being able to study the human figure relegated women to the rank of amateurs. Some critics were less hostile and felt that women had the same chance as men to master genre painting and portraiture, and easel painting in general.[89] However, the competitive presence of women artists in large numbers provoked tensions and brought social considerations to bear on artistic matters. The gendered construction of style had been a staple of eighteenth-century art criticism and theory, but no one could ignore that what the critics now designated as women's domain had been systematically presented as degrading work for artists when men alone were active.

As can be deduced from the recurrent comment that Labille-Guiard's portraits were painted by Vincent with whom she lived, it was common on the eve of the

Fig. 33. François Gérard, *Comtesse de Morel-Vindé and Her Daughter (The Music Lesson)*, 1799 (Salon of 1799). Fine Arts Museums of San Francisco, Museum Purchase, Mildred Anna Williams Fund and the William H. Noble Bequest Fund, 1979.8

Revolution to attribute a woman artist's work to a collaborator whenever mastery was manifest. Similar assertions continued to be made later. It was intimated that the grand history paintings of Mongez or the portraits by Benoist could not have been painted without David's help. When Davin-Mirvault first exhibited in 1802, one critic indicated that she studied with Suvée but had recently worked "under the direction of another master" because of the former's departure for Rome. He then added that the two paintings she exhibited "prove that she owes an immense debt to the cares [*soins*] of this new master and reaps much glory for the brush that produced them." The perverse critic concluded with a highly circumlocutory gloss on the names found in the catalogue, which raised doubts about her authorship.[90] Writers could belittle women's achievement without evoking the direct intervention of another artist simply by suggesting an imitation

tainted with servility: "It is easy to see, from the purity of the draftsmanship, that she is a pupil of David" was Bruun Neergaard's double-edged comment on Benoist's *Portrait of a Negress*.[91] Although such criticism was widely voiced on the occasion of the Salon of 1802, quite striking was the relative moderation two years later, as if the women painters—Benoist, Davin-Mirvault, and Romany—had become familiar figures whose progress and talent were acknowledged. Their portraits were finally accepted for what they were: creations with an authority of their own.

The works by Benoist and Davin-Mirvault in the present exhibition, the first shown at the Salon in 1802, the second in 1804, are prime examples of David's influence on the two painters. Distinctive is the sentimental sweetness of Benoist's figures and Davin-Mirvault's fascination with textures and surface effects, but the format of their portraits, the construction of the pose, the pyramidal composition, the neutral background, and generally the plenitude of form all suggest a filiation with his art. Significantly, both works, which entered their respective collections under David's name about fifty years ago, have been correctly reattributed, not on stylistic or formal grounds, but on the basis of rigorous documentary findings. On the occasion of this exhibition, placed alongside David's *Penrose* and *Suzanne Le Peletier* as well as other paintings of the period, these works should finally be viewed and appreciated as expressions of talented individual artistic personalities.

More provocatively still, the exhibition also puts to the test the notion that David was attentive to the emergence of women artists. That he maintained informal pedagogic contact with several of them indicates that he felt there was something to gain in the relation. Finding himself estranged from the other artists working for the Empire and unable to draw inspiration from a new generation of pupils who failed to assert themselves like the talented first group he had taught, David may have found in the art of Mongez, Benoist, and Davin-Mirvault perspectives and resources for the permanent artistic regeneration that was the key to his creative longevity.[92]

1. The recent innovative research of several art historians has been of great benefit to this project. Foremost among them is Tony Halliday, who in 1999 published the book *Facing the Public*, subtitled *Portraiture in the Aftermath of the Revolution*, which underlines the artistic prestige newly acquired by the genre and its practitioners during the Directory and Consulate. The period witnessed the breakdown of the traditional distinction between the exemplary public portrait and the normative private image, to the advantage of the latter. In the process, the notion of the private acquired added meaning. As well as providing a ground for the affirmation of personal identity, this locus of social reality was vaunted as the refuge of ethics and morality after the rampant deceitfulness on the public scene during the Terror. In this context, as Halliday explains, portraits by relatively minor draftsmen and miniaturists like Jean-Baptiste Isabey and Jean-Baptiste Jacques Augustin and by ambitious history painters like Anne-Louis Girodet and François Gérard are the focus of critical attention and assure their authors success and renown. As the favorable report on a translation of Adam Smith in the French press in 1795 intimated, the tyranny of virtue—the Jacobin Terror of 1793–94—was henceforth well supplanted by the rule of commerce.

From his reading of the reviews of the Salon of 1801, Halliday concludes that a woman painter, Nisa Villers, stole the show that year. The following year, about a third of the portraits exhibited were by women. As several articles in the press confirm, an exceptionally large number of women appeared on the Parisian artistic scene. Halliday provides a fundamental discussion of the phenomenon, which is assessed in the last section of this essay ("Portrait Modes and Codes during the Consulate"). Many of the painters he invokes have been studied by the art historian Margaret A. Oppenheimer, in a series of corrective articles published in 1996–97 (see, for example, articles cited in n. 53 and p. 65 n. 2). To Marie-Guillemine Benoist, Sophie Guillemard, Angélique Mongez, Adèle Romany, Eugénie Servières, and Nisa Villers, she restored the authorship of a host of paintings sent to the Consulate and Empire Salons. In the present exhibition, the portrait by Benoist (pl. 1) is one of her recent reattributions.

David's art about 1800 has recently stimulated a number of particularly attentive and nuanced commentaries. The two last chapters of Thomas Crow's *Emulation: Making Artists for Revolutionary France* (1995; for full citations, see n. 14), a dramatization of David's studio as the site of creative passions unleashed in the 1780s and 1790s, chart the pentecostal dispersion of pupils that ensued during the Consulate and Empire. Darcy Grimaldo Grigsby, in an article on *The Intervention of the Sabine Women* (1998; for full citation, see n. 17), addresses the question of David's relation to the social culture of his time. In *Necklines: The Art of Jacques-Louis David after the Terror* (1999),

Ewa Lajer-Burcharth argues that during the Directory "the uncertainty of artists about their identity and status as professionals was underwritten by a deeper, psychic, not just material, insecurity" (p. 208) and concludes with a forceful interpretation of David's portrait of Juliette Récamier and his uneasy dealings with his patroness. The first section of this essay engages, directly and indirectly, with some of their positions.

2. "Thermidor" is an abbreviated reference to 9 thermidor of the Republican Year II (July 27, 1794), the date on which Robespierre was ousted from control of the Committee of Public Safety and the National Convention.

3. Amaury Lefébure, "La première exposition des produits de l'industrie française en l'an VI (1798)," in *La Révolution française et l'Europe, 1789–1799*, exh. cat., Paris, Grand Palais, ed. Jean-René Gaborit, 1989, vol. 3, pp. 908–9. Jacqueline Viaux, "Les expositions des produits de l'industrie, 1798–1849," in *De Arte et Libris. Festschrift Erasmus, 1934–1984* (Amsterdam, 1984), pp. 427–49.

4. "Comme les peintres d'histoire ont aussi besoin de vivre, Gérard, comme plusieurs de ses confrères, a fait aussi des portraits." Kotzebue Year XIII-1805, vol. 2, p. 80. This dilemma was evoked in art criticism since the middle of the eighteenth century. For examples, see Wrigley 1993, p. 303.

5. The painting by Marie-Gabrielle Capet (1761–1818), exhibited at the Salon in 1808, is an homage to the school of Vincent, claiming for him the heritage of Vien. See Thomas Gaehtgens, "Eine gemalte Künstlergenealogie. Zu Marie-Gabrielle Capets Atelierszene in der Münchener Neuen Pinakothek," in *Kunst und Geschichte. Festschrift für Karl Arndt zum siebzigsten Geburtstag*, ed. Marion Ackermann, Annette Kanzenbach, Thomas Noll, and Michael Streetz, *Niederdeutsche Beiträge zur Kunstgeschichte* (Munich and Berlin, 1999), vol. 38, pp. 209–19.

6. Madame Campan, in April 1800, warning Hortense de Beauharnais of the danger of abandoning Isabey as her drawing master for David or one of his younger pupils: "Vous vous ferez des ennuis dans son parti, car chaque artiste a le sien" (You will raise trouble for yourself with his party, for each artist has his). Madame de Basily-Callimaki, *Jean-Baptiste Isabey, sa vie, son temps, 1767–1855* (Paris, 1909), p. 42.

7. "Ne croyez pas, cher ami, que le désir seul d'avoir mon portrait m'ait déterminé à vous engager à le faire. Non: je vous ai plus considéré que moi-même; j'ai voulu posséder un de vos chefs-d'œuvre et j'ai voulu plus encore avoir dans ce portrait un monument éternel de mon étroite liaison avec le premier peintre de l'Europe." Letter of 8 frimaire Year IV (November 29, 1795); David 1880, p. 324.

8. The foliage on the right of the picture was painted over to reinforce the sense of domination over nature, but pentimenti have come through.

9. Only the portrait of Emilie Sériziat is announced in the *livret* of the Salon, but references by several critics to the portrait of Pierre Sériziat confirm that it was also exhibited. David did not finish it in time for the opening and submitted it at a later date. New light on his strategy for this first Salon participation after his imprisonment is shed by a hitherto unknown letter dated 29 fructidor Year III (September 15, 1795) to the sculptor Joseph Espercieux, which indicates his satisfaction that the portrait of the "citoyenne d'Orvilliers" will not be exhibited (presumably the portrait of Robertine Tourteau, marquise d'Orvilliers, dated 1790, Musée du Louvre); his estimation that the "trois autres" he plans to send are better (explicitly those of the "citoyennes Lecoulteux et Hocquart" and implicitly that of Emilie Sériziat); and finally that his occupation with a fourth portrait (presumably that of Pierre Sériziat). Extracts of the letter are found in the catalogue *Les Autographes* (Paris), no. 106 (September 2003), no. 78 (Thierry Bodin generously allowed me to consult the letter). This mid-1790s dating for the lost portraits of the "citoyennes Lecoulteux et Hocquart," which at the time of the missive to Espercieux are not yet varnished, confirms what is suggested by a copy of the latter (sale, Paris, Hôtel Drouot, March 25, 1987, lot 39) on the basis of the dress and hairstyle, as Jeannine Baticle had astutely pointed out to me.

10. Kotzebue Year XIII-1805, vol. 1, p. 251. Such clichés are found fully articulated in plays such as J.-B. Pujoulx's *Les Modernes enrichis* (Paris, Year VI-1798). John Carr's description, first published in 1803, was less disparaging (1807, p. 361): "A new race of beings, called the 'nouveaux enrichés' [*sic*], whose services have been chiefly auxiliary to war, at present absorb the visible wealth of the nation. Amongst them are many respectable persons." For a stimulating analysis of how Vincent, Prud'hon, and Jacques Réattu came to terms with this clientele, see Weston 1998.

11. Mona Ozouf, "Liberté," in *Dictionnaire critique de la Révolution française* (Paris, 1988), pp. 772–74.

12. Lajer-Burcharth 1999, pp. 64–70. David's two portraits are discussed as "an effort to represent gender and to reinstall himself on the psychosexual arena of subjective self-definition" (p. 66); her subtle visual reading of the two portraits is on occasion peremptory (when invoking normative signs of gender) or questionable (when considering pendant portraits a novelty).

13. It is rarely noted that although exhibited at the Salon of the Year IV (1796), Gérard's painting bears the date 1795.

14. See the discussion of these questions in Halliday 1999, pp. 48–97. On Gérard's portrait of Isabey, see also the incisive comments of Thomas Crow, *Emulation: Making Artists*
for Revolutionary France (New Haven and London, 1995), pp. 224–25; and Lajer-Burcharth 1999, pp. 209–11.

15. "Je n'expose plus au Salon pour des raisons qu'il serait trop long de vous décrire; vous avez été assez témoin de la conduite des artistes à mon égard dans le temps de mes malheurs, et c'étaient ceux qui avaient le plus à se louer de moi qui m'ont le plus accablé." Wildenstein 1973, p. 152, no. 1350, letter of 8 messidor Year VIII (June 27, 1800).

16. "Je suis occupé en ce moment à faire une autre belle femme, Madame Récamier. C'est un tout autre genre de beauté. Je pense qu'elle voudra que son portrait soit exposé, alors j'aurai l'honneur, citoyen Préfet, de vous en prévenir et de vous prier en même temps de me permettre d'y joindre celui de Madame de Verninac." Wildenstein 1973, pp. 152–53, no. 1350, letter of 8 messidor Year VIII (June 27, 1800). On the complementary nature of the portraits, see Lajer-Burcharth 1999, pp. 245–46.

17. Lajer-Burcharth 1999, pp. 265–66, 274–75 (quote). My reading is more receptive to the visual rapprochement with a print after a severe allegory by the sculptor Jean-Guillaume Moitte, proposed by Darcy Grimaldo Grigsby, "Nudity *à la grecque* in 1799," *The Art Bulletin* 80 (June 1998): 320–21, fig. 14. See also Aileen Ribeiro, *The Art of Dress: Fashion in England and France, 1750–1820* (New Haven and London, 1995), pp. 112–13, figs. 120–21.

18. Farington 1979, p. 1863 (September 20, 1802); Carr 1807, p. 148. Henry Redhead Yorke, in his impressions of Paris (London, 1804), concurred: "The public character of David is well-known and held in general detestation"; Yorke, *France in Eighteen Hundred and Two described in a series of contemporary letters*, ed. J. A. C. Sykes (London, 1906), p. 125. The artist was even rumored to have poisoned Jean-Germain Drouais after having the latter paint the *Horatii* for him: "Davids äußerst widriges Äußere und menschenscheues, finsteres Wesen und Leben muß bei den leichtgläubigen Parisern alle dergleichen Gerüchte gegen seinen Charakter nur zu leicht begünstigen" (David's extremely unpleasant demeanor and antisocial, sinister conduct and way of life all too easily encourage gullible Parisians to spread such rumors attacking his reputation). Reichardt 1804, vol. 1, p. 479; the German edition published in Berlin in 1981 is abridged, as is the unreliable French translation published in Paris in 1896 and reedited in 2003.

19. *Souvenirs de Mme Vigée Le Brun* (Paris, n.d. [1867]), vol. 2, p. 50; the marriage project was initiated by her husband while she was in Russia. On Robert Lefèvre's portrait of Guérin in Orléans (signed and dated An 9), see the entry by Jean-Pierre Cuzin in *De David à Delacroix* 1974, p. 523, no. 119; and Halliday 1999, pp. 199–201.

20. Jean Rilliet and Jean Cassaigneau, *Marc-Auguste Pictet ou le rendez-vous de l'Europe universelle, 1752–1825* (Geneva, 1995), p. 202 (May 24, 1802): "Belle figure, vie fort réglée entièrement voué comme il est au travail." On Pictet's nephew, Adolphe Lullin, see pp. 147–48; and Etienne-Jean Delécluze, *Louis David, son école et son temps. Souvenirs* (Paris, 1855), reedited by Jean-Pierre Mouilleseaux (Paris, 1983), pp. 97–105.

21. "Brumaire" is an abbreviated reference to 18 brumaire of the Republican Year VIII (November 9, 1799), the day Bonaparte launched his assault on the Directorial regime.

22. How and why David placed his talent at the service of General Bonaparte, and later the First Consul and the Emperor Napoléon, are questions not developed here, as they constitute the core theme of a forthcoming essay for the catalogue of the exhibition *Jacques-Louis David: Empire to Exile,* which the J. Paul Getty Museum in Los Angeles and the Sterling and Francine Clark Art Institute in Williamstown, Massachusetts, will present in 2005.

23. Antoine Schnapper, *David témoin de son temps* (Paris, 1980).

24. With the help of "an Italian friend" who introduced him to the painter, according to unverifiable family recollections (a sheet of notes dated 1966 by Rupert Barneby in the Timken Museum file).

25. "La ville des sciences et des arts, la nouvelle Athènes": the expression is used by David's friend Pierre Chaussard specifically to convey the image of the capital for travelers and foreigners in his brochure, *Monuments de l'héroïsme français* (Paris, n.d. [1799–1800]), p. 4.

26. Biographical information is based on Hugo Read, "The Penroses of Woodhill, Cork: An Account of Their Property in the City," *Journal of the Cork Historical and Archaeological Society* 85 (1980): 79–98. Penrose's iconography, biography, and collection merit further research in Cork and Dublin; regrettably, inquiries to determine whether he left personal papers and documents relative to his collection, addressed to the Cork Archives Institute and the National Gallery of Ireland, failed to receive a response.

27. Will West, *A Directory and Picture of Cork and its Environs* (Cork, 1810), pp. 18–21. Max (J. P.) McCarthy kindly brought this brochure to my attention and furnished me with a copy of the relevant pages.

28. This information is extracted from correspondence with various descendants through the mid-1980s, in the Timken Museum files. Attempts to locate documents and works from Penrose's collection that might still be in family hands have not yet been successful. Kathleen Watchorn was most helpful in this search.

29. Richard Harrison, "The Cork Anti-Slavery Society, Its Antecedents and Quaker Background, 1755–1859," *Journal of the Cork Historical and Archaeological Society* 97 (1992): 70.

30. Pressly 1981, p. 222 n. 24 (the obituary appeared in March 1806); on the provenance of Barry's *Venus,* see p. 229.

31. *Monthly Magazine* 16 (September 1, 1803): 107, letter dated July 15, 1803 (cf. Pressly 1981, p. 303).

32. Pressly 1981, pp. 179–181, 222 n. 22.

33. Farington 1979, p. 1862 (September 20, 1802).

34. William Vaughan, "'David's Brickdust' and the Rise of the British School," in *Reflections on Revolution: Images of Romanticism,* ed. A. Yarrington and K. Everest (London, 1993), pp. 134–58. The expression in the title was coined by Benjamin Robert Haydon in 1841 (p. 134).

35. Farington 1979, p. 1860 (September 19, 1802). Maria Edgeworth concurred in a letter of December 6, 1802: "David is the best French painter but he is democrate enragé." *Maria Edgeworth in France and Switzerland: Selections from the Edgeworth Family Letters,* ed. Christina Colvin (Oxford, 1979), p. 46.

36. John Carr relates his visit to David's home during the Peace of Amiens (1807, p. 145): "I found David in his garden, putting in the back ground of a painting, dressed in a dirty robe, and covered with an old shabby hat. His eyes are dark and penetrating, and beam with the lustre of genius. His collections of paintings and statues, and many of his own studies, afforded a perfect banquet, and he was then occupied in drawing a fine portrait of Bonaparte. The presence of David covered the gratification with gloom. Before me, in the bosom of that art, which is said, with her divine associates, to soften the souls of men, I beheld the remorseless judge of his sovereign, the destroyer of his brethren in art, and the enthusiastic admirer and confidential friend of Robespierre." Carr apostrophizes the painter, concluding by a dramatic invocation of "the pale, shuddering, and bleeding victims of thy sanguinary soul!" (p. 147).

37. The marquise de Santa Cruz, who evokes her contacts with numerous artists while in Paris in 1801, in a series of letters to Lucien Bonaparte in Madrid, writes on August 18, [1801], concerning a future portrait commission: "Je vais faire la connaissance de Gérard qui dit on est le meilleur après David, et moins cher" (I am going to meet Gérard who is said to be the best after David, and less expensive). Correspondence in a private collection, generously brought to my attention by Jeannine Baticle.

38. David's concern to endow each of his four children equally would preoccupy him until the end of his life (see the forthcoming essay, mentioned in n. 22). "Unter den Künstler wird keiner für reich geachtet als David, der aber ein ganz scheues, eingezognes Leben führt und mit neimanden umgeht; auch hat

er eine sehr zahlreiche Familie" (Among artists, the only one said to be rich is David, who lives in total isolation and retreat and mixes with nobody; also he has a very large family). Reichardt 1804, vol. 3, p. 170.

39. The undated manuscript note was joined to the portrait when the Penrose family sold it and is now in the Timken Museum: "Que Monsieur Penrose se fie entièrement à moi, je lui ferai son portrait pour deux cents louis d'or. Je le représenterai d'une manière digne de tous les deux. Ce tableau sera un monument qui attestera à l'Irlande les vertus d'un bon père de famille, et les talens du peintre qui les aura tracées. On s'acquittera en trois payemens. Savoir 50 louis en commençant, 50 louis quand le tableau sera ébauché, et les 100 louis restans quand l'ouvrage sera achevé."

40. In his published annotations to Kotzebue (Year XIII-1805, vol. 2, p. 199 n. 1), R.-C. G. de Pixérécourt gives the current price range for a "simple portrait." Greatheed 1953, p. 32 (January 20, 1803): "The price of the portraits [by Gérard] is prodigious; for a full length 250 pounds." This is the equivalent of 250 louis or 6,000 livres or 5,000 francs (see examples of exchange rates in Farington 1979, pp. 1896, 1898; cf. Carr 1807, pp. 29–32). Prices for private commissions probably went down as Dominique-Vivant Denon began to moderate fees paid by the government to artists for official portraits. In September 1803 Gros received 9,000 francs for three full-length portraits of the First Consul. *Vivant Denon, Directeur des Musées sous le Consulat et l'Empire. Correspondance (1802–1815)*, ed. Marie-Anne Dupuy, Isabelle le Masne de Chermont, and Elaine Williamson, 2 vols. (Paris, 1999), vol. 1, p. 114. By 1805 the fixed price for similar works commissioned from Gérard, Gros, and many others was only 2,000 francs (p. 248). See also Halliday 1999, p. 189 n. 1 (citing Greatheed and offering further comparative information).

41. For a suggestive discussion of paternal and family values during this period, see Hunt 1992, pp. 17–52 ("The Rise and Fall of the Good Father"), 151–91 ("Rehabilitating the Family").

42. "Nul n'est bon citoyen, s'il n'est bon fils, bon père, bon frère, bon ami, bon époux": Jean-Pierre Machelon, "La constitution du 5 fructidor an III (22 août 1795): archaïsme ou modernité?" in *Constitution de l'an III. Boissy d'Anglas et la naissance du libéralisme constitutionnel*, ed. G. Conac and J.-P. Machelon (Paris, 1999), p. 42 (cf. Hunt 1992, p. 163, citing Joseph Goy, "La Révolution française et la famille," in *Histoire de la population française*, ed. J. Dupâquier, A. Sauvy, and E. Le Roy Ladurie [Paris, 1988], p. 93).

43. David gave Isabey his prison *Self-Portrait* around this time, a few years after painting it, according to one source (*David* 1989, p. 304): this strongly symbolic gesture was surely not gratuitous and suggests David's attentiveness to his former pupil's work.

44. The marquise de Santa Cruz visited his studio (letter of August 21, [1801], as in n. 37 above).

45. See the two prints after P. A. Wille fils (1795–96) reproduced in *Premières Collections*, exh. cat., Vizille, Musée de la Révolution française, ed. Philippe Bordes, 1985, p. 52, nos. 82–83. The *sedia gestatoria* is the pope's portable throne.

46. Strictly speaking, the imperfect—*faciebat*—should be translated as "was painting." The imperfect tense of Greek inscriptions found on antique statues, glossed by Pliny the Elder, was interpreted since the late fifteenth century as a mannerism of modesty, which many artists later imitated in Latin (my thanks to Christian Michel for this observation); see Vladimir Jŭren, "Fecit Faciebat," *Revue de l'art*, no. 26 (1974): 27–30.

47. Farington 1979, pp. 1861 (quote), 1863 (September 20, 1802): "there were many casts of figures & busts, and drapery hung up & studiously folded and nailed to secure the forms in which it was so placed." See also Carr 1807, pp. 144–45.

48. Farington 1979, pp. 1824–25 (September 3, 1802), 1861 (September 20), 1891 (October 10).

49. John Newman, "Reynolds and Hone. 'The Conjuror' Unmasked," in *Reynolds*, exh. cat. (London, Royal Academy of Arts, ed. Nicholas Penny, 1986), pp. 344–54; see also p. 343, no. 173.

50. Farington 1979, p. 1891 (October 1, 1802).

51. Greatheed 1953, p. 26 (letter dated January 16, 1803); for David's *Bonaparte* and Hogarth, see p. 25. Mark Ledbury has discovered a letter from David's wife to the banker Perrégaux, dated 8 floréal Year XI (May 28, 1803) confirming that Penrose's portrait was still in Paris at that date: "Paris 8 Floreal 11e / A Monsieur Perregaux senateur rue du mont blanc / Je vous envoye Monsieur la lettre que j'ai écrit a Monsieur Penerosse [*sic*] et dans laquelle je lui marque que vous voulez bien avoir la complaisance de lui écrire pour concerter ensemble le moyens de lui faire passer son portrait qui est chez moi. / Agréez l'assurance de ma parfaite considération / Femme David / Ce jeudi 8 floreal." Bibliothèque municipale, Nantes, MS français 656[38]. The main passage reads: "Sir, I am sending the letter I wrote to Mr. Penrose in which I indicate that you will kindly be writing to him to make arrangements to send him his portrait which is at my home."

52. Reichardt 1804, vol. 1, p. 192.

53. On this portrait, see *De David à Delacroix* 1974, p. 383, no. 42 (entry by Jacques Foucart); reproduced p. 91, pl. 47. Marie-Denise, called Nisa, Villers adopted this strategy at the Salon of 1802 with a painting showing a woman on a walk in the countryside, part of her face veiled, in the process of tying her slipper; although she called it *Etude de femme d'après nature*, it seems to have been perceived as a portrait on account of the

format and scale. See Margaret A. Oppenheimer, "Nisa Villers, née Lemoine (1774–1821)," *Gazette des Beaux-Arts*, April 1996, p. 165, fig. 1.

54. Farington 1979, p. 1894 (October 2, 1802).

55. Farington 1979, p. 1898 (October 3, 1802).

56. Farington 1979, p. 1903 (October 6, 1802). On October 8, the day he left Paris, Farington called one last time on "Madamselle Julia and took letters from her" (p. 1908). She continued to be in contact with David after that date, for on November 7 the diarist reported that she "told R. Smirke that the public admiration of it [Guérin's *Phèdre et Hippolyte*] had excited uneasy sensation in the mind of David, whose work the Sabine Women was now called for it being improper for him to exhibit for money since such a picture as Hypolitus is placed in the public exhibition" (p. 1930).

57. *Monthly Magazine* 16 (September 1, 1803): 107, letter dated July 15, 1803 (cf. Pressly 1981, p. 303).

58. "Ainsi tout est idéal, tout est magique dans l'art. Il fait entrer le mensonge jusque dans ses expressions les plus précises de la vérité; il fascine les yeux des spectateurs, et pour leur offrir la représentation d'un objet, il emploie encore plus le prestige que l'imitation fidèle. Si le portrait lui-même est un mensonge, il ne sera jamais mieux traité que par l'artiste qui, en s'exerçant dans le genre de l'histoire, s'est accoutumé aux grands mensonges de l'art." Watelet and Lévesque 1972, vol. 5, p. 159, full entry, pp. 145–59. A first edition was published as part of the *Encyclopédie méthodique: Beaux-Arts*, 2 vols. (often bound in 4) (Paris, 1788–91) (cf. Halliday 1999, pp. 34–35). On this authoritative and widely diffused publication, see Christian Michel, "Deutsche Ästhetik und französische Kunsttheorie am Ende des Ancien Régime. Die «Encyclopédie méthodique: Beaux-Arts»," in *Jenseits der Grenzen. Französische und deutsche Kunst vom Ancien Régime bis zur Gegenwart. Thomas Gaetghens zum 60. Geburtstag*, ed. U. Fleckner, M. Schieder, and M. Zimmermann (Cologne, 2000), vol. 1, pp. 329–44.

59. Halliday 1999, pp. 157–61; Boutard's praise in 1804 for the skill with which portrait painters labored over accessories, discussed by Halliday (p. 161), is mentioned below. For a wide range of contributions to the debate on the relation between portraiture and history painting, see references in Wrigley 1993, pp. 301–3.

60. On the early history of the seated portrait, see, for example, Joanna Woodall, "An Exemplary Consort: Antonis Mor's Portrait of Mary Tudor," *Art History* 14, no. 2 (June 1991): 192–224. Illustrated (p. 212, fig. 34) is Titian's full-length *Emperor Charles V*, with the figure seated (1548, Alte Pinakothek, Munich).

61. See the conveniently illustrated repertory of academic "morceaux de réception" in *Les peintres du roi, 1648–1793*, exh. cat., Tours, Musée des Beaux-Arts, and Toulouse, Musée des Augustins, ed. Philippe Le Leyzour and Alain Daguerre de Hureaux, 2000, pp. 222–83.

62. Schnapper, in *David* 1989, pp. 227–28.

63. Anatole de Montaiglon and Benjamin Fillon, "Artistes français en 1800," *Nouvelles Archives de l'art français*, 1872; reprint, 1973, pp. 432–37.

64. Bruun Neergaard Year IX-1801, pp. 12–13: ". . . c'est au point que plusieurs particuliers, qui savent à peine manier le crayon, se sont faits peintres en portraits; et Paris fourmille de gens qui ont choisi ce genre, le jugeant plus facile"; 13: ". . . il est difficile d'atteindre à un certain degré de perfection, car peu l'ont acquis, excepté un Gérard et un Girodet, qui ont eu pour maître le grand peintre d'histoire, David. Si ces artistes ont quelques avantages sur notre Juul, ce dernier en a aussi sur eux, comme peintre en portraits. Sa draperie surtout est la plus belle que je connaisse"; 39–44 (on portraits at the Salon of 1800).

65. Already at the Salon of 1795 a critic expressed fear that the "nouvelle méthode" based on the imitation of antique models would yield "des productions sèches et froides"; the following year, a neoclassical composition by Jean-Joseph Taillasson was judged "d'un mérite glacial." See Régis Michel, in Bordes and Michel 1988, pp. 65, 72. Many more cautionary remarks of this sort followed in later years.

66. "Je ne connais qu'un tort à cet artiste, c'est d'avoir rendu ce portrait avec tant d'art et de vérité qu'il paraît lui avoir coûté beaucoup de temps. Celui qu'il a perdu à lustrer un habit aurait pu être employé à lustrer un chef-d'œuvre historique": *Bulletin universel des sciences, des lettres et des arts*, no. 4, 5 frimaire Year IX [November 28, 1800]: 27; mentioned by Halliday (1999, p. 104 n. 28) and cited by Jean Lacambre in *De David à Delacroix* 1974, p. 450; cf. Philip Conisbee in *Portraits by Ingres* 1999, p. 26.

67. Lafont 1999, pp. 52–53; when writing her article, the author had not been able to see the *Geography Lesson*, which is clearly signed and dated 1803. A similar trompe l'oeil effect is found in a Girodet portrait of 1800 (p. 52, fig. 9); in both instances the insect is in the composition and not an illusion painted on the surface of the canvas. For a pertinent discussion, see Anne-Marie Lecoq, "La mouche et le rideau," in *La peinture dans la peinture*, exh. cat., Dijon, Musée des Beaux-Arts, ed. Pierre Georgel and A.-M. Lecoq, 1982, p. 271.

68. Udolpho Van de Sandt, " 'Grandissima opera del pittore sarà l'istoria'. Notes sur la hiérarchie des genres sous la Révolution," *Revue de l'art*, no. 83 (1989): 71–76.

69. Wrigley 1993, p. 303; Halliday 1999, p. 161. For the reception of Ingres's early portraits, see Andrew Shelton in *Portraits by Ingres* 1999, pp. 497–501. It is noted here by Kimberly Jones that in his portrait of the comtesse de Tournon (1812, Philadelphia Museum of Art), Ingres chose "a more stolid, almost masculine pose, very similar to that used in the portrait of Philibert Rivière" (p. 138): the young painter associates the once modern Davidian conception with the representation of the elderly.

70. Nicole Garnier-Pelle, *Chantilly. Musée Condé. Peintures des XIXe et XXe siècles* (Paris, 1997), pp. 155–56, no. 103.

71. On Lethière's portrait, see *European Paintings in the Collection of the Worcester Art Museum*, ed. Louisa Dresser, 2 vols. (Worcester, Massachusetts, 1974), vol. 1, pp. 260–61.

72. Halliday (1999, pp. 177–80) offers an excellent discussion of the rivalry with Bonaparte as the backdrop for commentary on Gérard's portrait of Moreau (location unknown; oil sketch reproduced p. 178).

73. Bruun Neergaard Year IX-1801, p. 119: "La manière de faire de cet artiste est si variée dans ce tableau, qu'on est embarrassé de savoir à qui on doit l'attribuer." Gérard's *Murat* is at the Musée national des Châteaux de Versailles et des Trianons and reproduced by Halliday (1999, p. 170), who considers it a "humorous pastiche" of royal portraits of the Ancien Régime (p. 169). Gérard's portrait of Josephine, signed and dated 1801 (Hermitage, Saint Petersburg), is reproduced in color in V. Beresina, *La Peinture française. Première moitié et milieu du XIXe siècle. Musée de l'Ermitage. Catalogue raisonné* (Leningrad, 1983), unnumbered plates; text in Russian, p. 144, no. 201.

74. See Jean-Pierre Cuzin, in *La Collection Grenville L. Winthrop. Chefs-d'œuvre du Fogg Art Museum, Université de Harvard*, exh. cat., Lyons, Musée des Beaux-Arts, ed. Stephan Wolohojian, 2003, pp. 224–25, no. 84.

75. More than three hundred prints, including some portraits, were put on sale in 1798–99: *Catalogue et prix des estampes, et caricatures anglaises. Exposés en vente à la grande galerie d'estampes, etc.; au ci-devant couvent des Capucines, Place Vendôme, au premier dans les corridors de la grande cour* (Paris, Year VII).

76. Chaussard's argument that Prud'hon's *exemplum virtutis* failed was surely overdetermined by the adoption of the female nude (cf. Weston 1998, p. 166).

77. For basic information on the artist, see *Prud'hon ou le rêve du bonheur*, exh. cat., Paris, Grand Palais, ed. Sylvain Laveissière, 1997. Bruun Neergaard Year XI-1801, pp. 120–37.

78. Bruun Neergaard Year XI-1801, p. 120: "C'est le peintre des Grâces; quelques-uns même l'appellent le Corrège français." The latter appellation is already found in a letter from Etienne Mayeuvre de Champvieux to Jean-Jacques de Boissieu dated September 24, 1798. Marie-Félicie Pérez, "Quelques lettres concernant Jean-Jacques de Boissieu (1736–1810)," *Archives de l'art français*, n.s., 28 (1986): 125.

79. Halliday 1999, p. 197 n. 17. The source is an anonymous letter full of sarcasm in the *Journal des arts, des sciences et de littérature*, no. 18 (30 vendémaire Year VIII [October 22, 1799]): 11–13; basically, the author condemns the artistic pretensions of the women painters and their neglect of family duties.

80. "Un Amateur" [Jacques-Philippe Voiart], who addressed his *Lettres impartiales sur les expositions de l'an XIII* to a woman, proposed an "exposition totalement féminine" (Paris, Year XIII-1804), letters XXXI–XLIV (C.D., vol. 31, no. 876), pp. 17–20 (letter XXXIV).

81. See the thorough development of this idea by Lajer-Burcharth 1999, pp. 130–204.

82. Halliday's conclusion—"In the long term, it was increasing intolerance of women's assumption of conspicuous rôles outside the family which excluded them from participation in public spaces such as the Salon" (1999, p. 197)—should thus be qualified. According to a reviewer in the *Moniteur* the Salon of 1808 was a "Salon de dames," with 50 women among the 410 artists exhibiting (cited by Geneviève Lacambre in *De David à Delacroix* 1974, p. 348). This rise in women's participation, to 70 in 1810, is noted by François Benoit, *L'art français sous la Révolution et l'Empire. Les doctrines, les idées et les genres* (Paris, 1897; reprint, Geneva, 1975), p. 245. On Mongez, see Margaret Field Denton, "A Woman's Place: The Gendering of Genres in Post-Revolutionary French Painting," *Art History* 21, no. 2 (June 1998): 219–46.

83. Bruun Neergaard Year IX-1801, pp. 17–18: "Beaucoup de femmes, par ton, cultivent la peinture, ou suivent certains cours d'histoire naturelle, mais il n'en est parmi elles que six ou sept qu'on puisse distinguer."

84. For Charpentier's *Melancholy*, see *De David à Delacroix* 1974, pp. 346–47, no. 19 (entry by Robert Rosenblum), p. 183, fig. 101; for Vincent's, see Maria Teresa Caracciolo, "La Malincolia settecentesca," *Antologia di Belle Arte*, n.s., nos. 39–42, *Studi sul neoclassicismo* 3 (1991–92): 5–16, 13, fig. 11.

85. Three portraits are in the Musée Fesch in Ajaccio: Lucien Bonaparte (exhibited at the Salon of 1799), his first wife, Christine Boyer, and Letizia Bonaparte, the First Consul's mother, the latter painted in an interior; see *Les Frères Sablet (1775–1815)*, exh. cat., Nantes, Musées départementaux de Loire-Atlantique, Lausanne, Musée Cantonal des Beaux-Arts, Rome, Museo di Roma, ed. Anne Van de Sandt, 1985, pp. 74–76, nos. 33–35. Jacques Sablet's studio was among those visited by foreigners during the Peace of Amiens. With Boilly, he also revived the small-scale portraits in an outdoor setting developed in the 1730s notably by Nicolas Lancret and practiced more recently in Britain and Italy.

86. For the contemporary discussion of his trompe l'oeil, see Susan Siegfried, *The Art of Louis-Léopold Boilly: Modern Life in Napoleonic France* (New Haven and London, 1995), pp. 191–95.

87. Watelet and Lévesque 1972, vol. 5, p. 154: "On trouve cette même naïveté de la nature dans les portraits faits en Angleterre depuis un petit nombre d'année. C'est par cette vérité que des tableaux de famille faits chez cette Nation offrent un intérêt touchant."

88. Gérard's *Henri Auguste and His Family* is lost but known from an oil sketch (reproduced and discussed by Halliday 1999, pp. 86–88, fig. 13). For the *Comtesse de Morel-Vindé and Her Daughter*, see Pierre Rosenberg and Marion C. Stewart, *French Paintings, 1500–1825: The Fine Arts Museums of San Francisco* (San Francisco, 1987), pp. 174–77. Gérard's practice of sytematically keeping small sketches (about 30 by 20 cm) after his life-size portraits raises the question of their appropriate scale.

89. Halliday 1999, p. 195; this position was in particular taken by the painter-critic Charles-Paul Landon. Halliday (pp. 195–96) observes that "in the short term, Landon's campaign was not conspicuously effective" and analyzes Benoist's *Portrait of a Negress* (Salon of 1800, Musée du Louvre) as a response to the hostile critic. Subsequently, Angélique Mongez's success at history painting forced Landon to denounce an inversion of rôles (*Salon de 1810*, p. 73): "lorsque quelques hommes d'un talent distingué se bornent à de petits ouvrages dont la mollesse et le fini minutieux semblent annoncer un pinceau féminin, il est glorieux pour Mme Mongez de traiter son art en homme expérimenté." The anonymous critic of the *Journal du Bulletin de Paris* in 1802 evokes the equal chances of men and women in the lower genres (C.D., vol. 30, no. 810, ms copy, pp. 23–24). In 1804, commenting on a portrait group by Constance Mayer, another critic circumscribed their domain: "La sensibilité et les grâces ne sont pas des domaines à dédaigner. L'amour est plutôt fait pour leurs pinceaux que Mars, et la femme sous l'habit d'un homme, ne paraîtra toujours qu'un homme faible." *Critique raisonnée des tableaux du Salon. Dialogue entre Pasquino, voyageur romain, et Scapin. . . .* (Paris, Year XIII-1804), pp. 46–47; C.D., vol. 31, no. 878.

90. She has worked "sous la direction d'un autre maître"; her two paintings "prouvent qu'elle doit infiniment aux soins de ce nouveau maître et donnent beaucoup de gloire au pinceau qui les a produits." The passage questioning her authorship: "Nous ne devons connaître que les noms que nous trouvons inscrits sur le livret; il ne nous appartient donc pas de prononcer entre la sévérité, soit injuste, soit équitable, qui dénie les progrès, et le talent, soit réel, soit emprunté qui les présente comme sa propriété: ces deux tableaux portent le nom de Madame Davin, ils ont beaucoup de mérite, et le devoir exige que nous n'en rapportions la gloire qu'à elle seule." *Journal des arts, des sciences et de littérature*, no. 232 (20 vendémiaire Year XI [October 12, 1802]): 98.

91. Bruun Neergaard Year IX-1801, p. 42: "Il est facile de voir, à la pureté du dessin, qu'elle est élève de David." In 1802 the *Revue du Salon* calls her David's "prête-nom" and quips, "Il est aisé de voir que David a moins travaillé à ce tableau [no. 17. *Portrait d'une jeune femme avec un enfant* (pl. 1)] qu'au précédent" (C.D., vol. 28, no. 766, p. 3); while the anonymous critic of the *Journal des arts, des sciences et de littérature* (no. 228, 30 fructidor Year X [September 17, 1802]: 426) deems that it is time for her to develop her own style.

92. With respect to portraiture, although David's influence on certain women painters about 1800 is manifest, it should be recalled that in the 1780s he had admired and profited from the example of Vigée Le Brun. It is possible to see his predilection for mythology, often on the theme of love, during the Empire and Restoration as an appropriation of iconography presented by the critics of the period as particularly suited to women.

PLATES

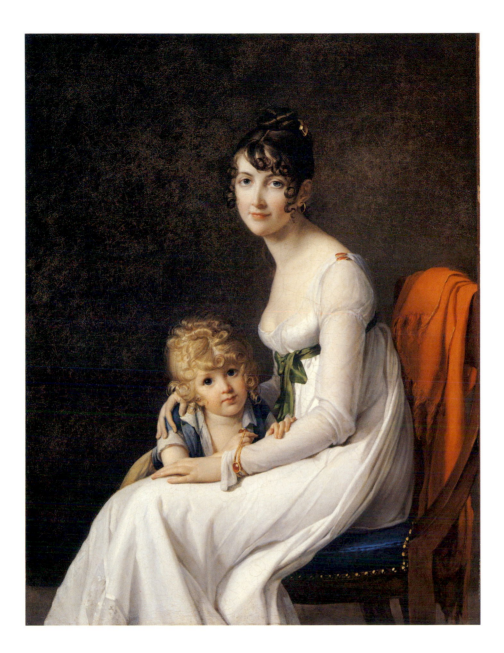

PLATE 1

MARIE-GUILLELMINE BENOIST NÉE LEROUX-DELAVILLE (1768–1826)

Madame Philippe Panon Desbassayns de Richemont (1778–1855) and Her Son, Eugène

The Metropolitan Museum of Art, New York. Gift of Julia A. Berwind, 1953 (53.61.4)
Photograph © 1996 The Metropolitan Museum of Art

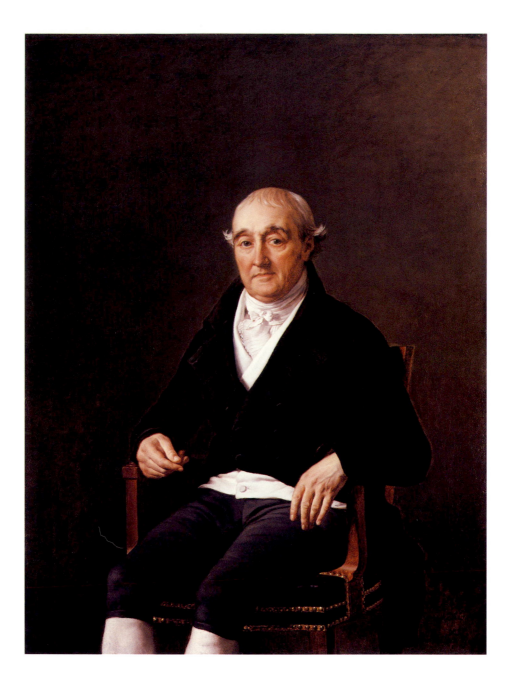

PLATE 2

JACQUES-LOUIS DAVID (1748–1825)

Portrait of Cooper Penrose

Signed and dated lower right: *L^{cus} David / faciebat / parisiis anno / X^{mo} / reipublica gallic[ae]*

The Putnam Foundation, Timken Museum of Art, San Diego

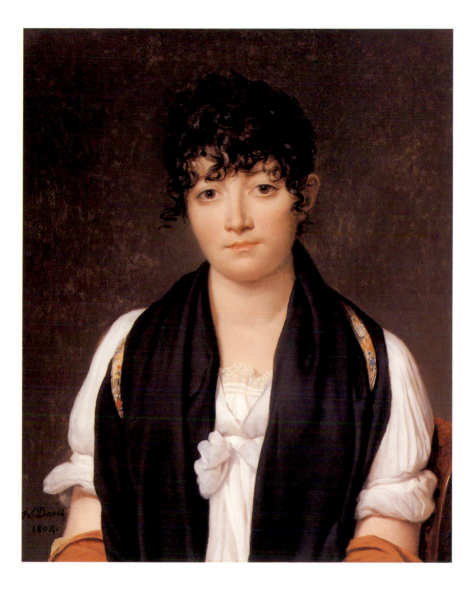

JACQUES-LOUIS DAVID (1748–1825)

Suzanne Le Peletier de Saint-Fargeau

Signed and dated lower left: *L. David / 1804*

The J. Paul Getty Museum, Los Angeles (97.PA.36)

PLATE 4

Césarine Davin-Mirvault (1773–1844)

Portrait of Antonio Bartolomeo Bruni

The Frick Collection, New York (52.1.160). Copyright The Frick Collection, New York

FRANÇOIS GÉRARD (1770–1837)

Portrait of Joachim Le Breton

Assemblée Nationale, Paris

PLATE 6

ANNE-LOUIS GIRODET (1767–1824)

Portrait of a Woman

Signed with a monogram and dated, lower right: *ALGDR / 1804*

Smith College Museum of Art, Northampton, Massachusetts. Purchased with the assistance of
the Eleanor Lamont Cunningham, class of 1932, Fund and the General Purchasing Fund (1956.19)

PLATE 7

ANTOINE-JEAN GROS (1771–1835)

Portrait of Jacques Amalric

Signed and dated lower left, scratched into the paint surface: *Gros. 1804*
(the last numeral has been tampered with to read also as a *9*)

Petit Palais, Musée des Beaux-Arts de la Ville de Paris, Paris (P DUT, 1303). © PMVP/Pierrain

51

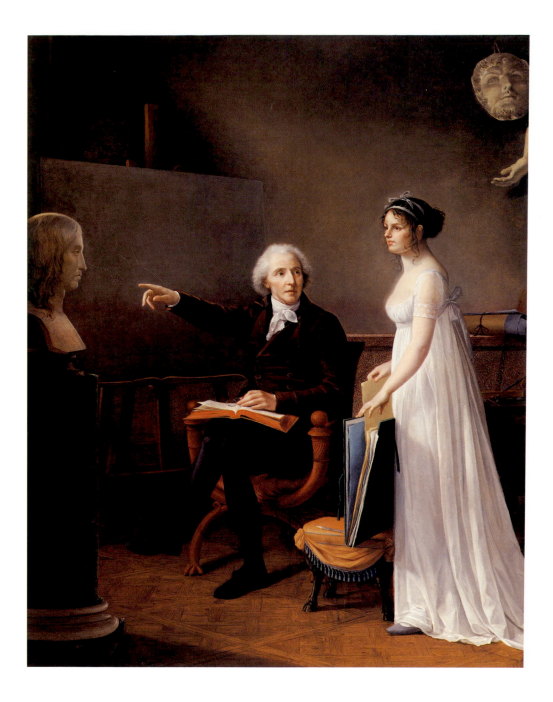

PLATE 8

CONSTANCE MAYER (1775–1821)

Self-Portrait of the Artist with Her Father

Wadsworth Atheneum, Hartford, Connecticut. The Ella Gallup Sumner and Mary Caitlin Sumner Collection Fund (1989.1)

PLATE 9

ADÈLE ROMANY, ALSO KNOWN AS ADÈLE DE ROMANCE (1769–1846)

Portrait of Louis Etienne Vigée

Signed and dated lower left: *Adele Roma . . . / 1800*

Private Collection

1.

MARIE-GUILLELMINE BENOIST NÉE LEROUX-DELAVILLE
(1768–1826)
*Madame Philippe Panon Desbassayns de Richemont (1778–1855)
and Her Son, Eugène*
Oil on canvas, 46 x 35¼ in. (116.8 x 89.5 cm)
The Metropolitan Museum of Art, New York
Gift of Julia A. Berwind, 1953 (53.61.4)
Photograph ©1996 The Metropolitan Museum of Art

PROVENANCE

Philippe Panon Desbassayns de Richemont (1774–1840) and his
wife, née Jeanne-Catherine-Eglé-Fulcrande de Mourgue
(1778–1855), and thence by descent (according to information
furnished by the family, cited by Oppenheimer [1996, p. 150
n. 7; see Literature]: given by the sitter to her brother Jean-
Scipion-Anne Mourgue [1772–1860], inherited by his niece,
Hélène Chabert née Mourgue [see Exhibited, 1897]; sold out
of the family in 1905); . . . ; René Gimpel and Wildenstein and
Co.; sold by Gimpel to E.-J. Berwind in 1918; after his death
(1936), his sister Julia A. Berwind; gift of Julia A. Berwind to
The Metropolitan Museum of Art, New York 1953 (53.61.4).

EXHIBITED

Paris, Salon of 1802, no. 17 (*Portrait d'une jeune femme avec un
enfant*); Paris, Ecole des Beaux-Arts, *Portraits de femmes et
d'enfants*, 1897, p. 23, no. 45 ("à M. Chabert"); London, Royal
Academy of Arts, *Exhibition of French Art, 1200–1900,* 1932,
uncatalogued (see Literature); Chicago, The Art Institute of
Chicago, *A Century of Progress*, 1933, p. 33, no. 213, pl. 47; New
York, The Metropolitan Museum of Art, *French Painting and
Sculpture of the XVIIIth Century*, 1935–36, no. 58; New York,
New York World's Fair, *Masterpieces of Art*, 1939, no. 80, pl. 84
(entry by Wilhelm R. Valentiner).

LITERATURE

*Revue du Salon de l'an X ou examen critique de tous les tableaux
qui ont été exposés au Muséum*, Paris, Year X-1802, p. 3 (C.D.,
vol. 28, no. 769); Henry Caro-Delvaille, "Jacques-Louis David,"
Art in America 7 (June 1919): 148, ill. 144 (collection of E. J.
Berwind); W. R. Valentiner, *Jacques-Louis David and the
French Revolution* (New York, 1929), fig. 14 opp. p. 26; W. R.
Valentiner, *Chefs-d'œuvre inconnus des grands maîtres* (Paris and
Brussels, 1930), vol. 1, p. 83; A. Frankfurter, "Thirty-five
Portraits from American Collections," *Art News*, May 16, 1931,
p. 4; Henri Focillon, "Sur le portrait français," *Formes*, no. 20
(December 1931): 165–67, ill.; Tancred Borenius, "Die
Ausstellung französischer Kunst in London," *Pantheon*,
January 1932, p. 19; Jacques-Emile Blanche, "L'exposition de
l'art français à Londres," *Gazette des Beaux-Arts*, January 1932,
p. 81, fig. 5; Ella S. Siple, "Art in America. Exhibition of
French Art in New York and Springfield," *Burlington Maga-
zine*, December 1939, p. 249; Gaston Brière, "Sur David
portraitiste," *Bulletin de la Société de l'histoire de l'art français*,
1945–46, p. 176; Agnes Humbert, *Louis David*, *Collection des
Maîtres* (Paris, 1947), no. 55, ill.; Elizabeth E. Gardner, "David's
Portrait of Madame de Richemont and Her Daughter," *Metro-
politan Museum of Art Bulletin* 3 (November 1953): 58–59;
Louis Hautecœur, *Louis David* (Paris, 1954), p. 188 n. 65; René
Gimpel, *Journal d'un collectionneur, marchand de tableaux* (Paris,
1963), pp. 46, 49, 113; Margaret A. Oppenheimer, "Three
Newly Identified Paintings by Marie-Guillelmine Benoist,"
Metropolitan Museum Journal 31 (1996): 143–51, ill. 144.

Until this portrait was reattributed to Benoist by Margaret
Oppenheimer, who identified it with a painting exhibited in
1802, it was generally associated with the art of David. Certain
specialists, however, found the execution too smooth for the
master; others expressed their doubts by ignoring the painting.[1]
The format and pose of the main figure recall the knee-length
portraits David painted in the early 1790s, while the insistence
on the affectionate relation between mother and young child
may be considered a variation on *Emilie Sériziat*. Benoist, like
David, chose to moderate the effusiveness shown in the two
self-portraits with her daughter that Vigée Le Brun had
painted in the late 1780s (Musée du Louvre). In other ways, her
art expresses a distinct personality. The fact that she contrasts
the alignment of the main figure and the picture plane with the
dramatic effect of the boy who comes forward from the back,
relishing the tension between the two figures, attests to an
experimental attitude toward pictorial unity that she shared
with painters of her generation. Further details of the picture
also characterize her independent artistic vision with respect to
David. The grace of the woman's body is underlined by the

elongated forms of the neck, arm, fingers, and thigh. Perhaps with reference to Renaissance representations of women, Benoist covers the sitter with jewelry: a pin in her hair, an earring, a shoulder clasp on her dress, and a bracelet, which amuses the child. The gaze of both figures seem to fix the viewer, and they strike a similar expression of beckoning sweetness also alien to David's art. Finally, a horizontal strip at the base of the composition is introduced to suggest perspectival depth. Benoist sent to the Salon in 1804 a three-quarter-length portrait of Jean-Dominique Larrey (Musée des Augustins, Toulouse) with the same device.[2] David, like Davin-Mirvault who avoided it in her portrait of Bruni (pl. 4), probably considered that such a visual effect created a problem of spatial ambiguity.

Larrey was Benoist's brother-in-law, and presumably many of her sitters were friends or relations. Philippe Desbassayns was a rich landowner from the island of La Réunion and had also been a marine official in the colonies, so there may have been a connection between the commission of his portrait and the painter's earlier decision to execute a *Portrait of a Negress* (Salon of 1800, Musée du Louvre). However, as a painter in Paris since the mid-1780s and the author of an impressive allegorical composition shown at the Salon of 1791, *Innocence between Vice and Virtue*,[3] Benoist (who exhibited under her husband's name only after her marriage in 1793) had built up a solid reputation over the years and was by far the woman painter best qualified to attract a variety of clients.

1. In a letter of July 15, 1970 (museum file), Robert Herbert found the handling less painterly than that of David; Antoine Schnapper made no mention of the painting in *David* 1989.

2. The portrait is identified, discussed, and reproduced by Oppenheimer 1996, pp. 147–48.

3. Viktoria Schmidt-Linsenhoff, "Herkules als verfolgte Unschuld? Ein weiblicher Subjektenwurf der Aufklärung von Marie Guillelmine Benoist," in *Die Verhältnisse der Geschlechter zum Tanzen bringen*, ed. Daniela Hammer-Tugendhat, Doris Nell-Rumpeltes, and Alexandra Pätzold (Marburg, 1991), pp. 17–46.

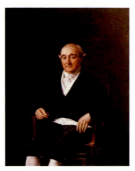

2.

JACQUES-LOUIS DAVID (1748–1825)
Portrait of Cooper Penrose
Oil on canvas, 51⅜ x 38⅜ in. (130.5 x 97.5 cm)
Signed and dated lower right: *L^{cus} David / faciebat / parisiis anno / X^{mo} / reipublica gallic[ae]*
The Putnam Foundation, Timken Museum of Art, San Diego

PROVENANCE

Cooper Penrose (December 4, 1736–February 25, 1815) and thence by descent until 1947 (Cooper 1949, see Literature: "A really fine signed and dated [1801] [*sic*] portrait by David, that of *Mr Penrose* . . . , which had been lost sight of, was recently disposed of by the descendants of the sitter and has left the country"); acquired by Wildenstein & Co., New York, 1947; acquired by the Putnam Foundation, 1953.

EXHIBITED

New York, The Metropolitan Museum of Art, extended loan, 1953–55; Cambridge, Massachusetts, The Fogg Art Museum, extended loan, 1955–65; Houston, The Museum of Fine Arts, 1986–87, *A Magic Mirror: The Portrait in France, 1700–1900*, cat. by George T. M. Shackelford and Mary Taverner Holmes, pp. 78, 131, no. 23, ill.

LITERATURE

A. Th., *Vie de David* (Paris, 1826), p. 166 ("M. Pennerin Villandois"); Charles Blanc, *Histoire des peintres français au XIX^e siècle* (Paris, 1845), p. 211; Charles Blanc, "Ecole française. Louis David," fascicle publication (16 pp., with printed cover) for the *Histoire des peintres de toutes les écoles depuis la Renaissance jusqu'à nos jours* (Paris, n.d. [after 1849]), p. 15 ("M. Pennerin-Villandois"); David 1880, p. 642; Joseph Farington, *The Farington Diary*, ed. James Greig, 8 vols. (London, 1922–28), vol. 2, pp. 45–46; Richard Cantinelli, *Jacques-Louis David* (Paris and Brussels, 1930), p. 110, no. 100; Klaus Holma, *David, son évolution et son style* (Paris, 1940), p. 128, no. 106; Douglas Cooper, "The David Exhibition at the Tate Gallery," *Burlington Magazine*, January 1949, p. 22; Agnes Mongan and Elizabeth Mongan, *European Paintings in the Timken Art Gallery* (San Diego, 1969), pp. 100–101, 132–33,

no. 38, ill.; Wildenstein 1973, p. 161, no. 1386, p. 209, no. 1810, p. 226, no. 1938; Farington 1979, p. 1891; Antoine Schnapper, *David, témoin de son temps* (Paris, 1980), pp. 208, 210, ill. 211, fig. 121; Antoine Schnapper, *David* (New York, 1982), pp. 208, 210, ill. p. 211, fig. 121; *Timken Art Gallery: European and American Works of Art in the Putnam Foundation Collection* (San Diego, 1983), pp. 42–43, 118–19, no. 13, ill.; Luc de Nanteuil, *Jacques-Louis David* (New York, 1985), pp. 56, fig. 75, 69; Luc de Nanteuil, *Jacques-Louis David* (Paris, 1987), pp. 56, fig. 75, 69; *David 1989*, pp. 19, 21, 375, fig. 93, in reverse, 601 (entry by Antoine Schnapper); *Timken Museum of Art: European Works of Art, American Paintings, and Russian Icons in the Putnam Foundation Collection* (San Diego, 1996), pp. 147–51, no. 27, ill. 148 (entry by Richard Rand).

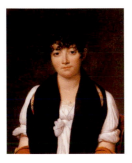

3.

JACQUES-LOUIS DAVID (1748–1825)
Suzanne Le Peletier de Saint-Fargeau
Oil on canvas, 23⅞ x 19½ in. (60.5 x 49.5 cm)
Signed and dated lower left: *L. David / 1804*
The J. Paul Getty Museum, Los Angeles (97.PA.36)

PROVENANCE

Suzanne Le Peletier de Saint-Fargeau (March 1, 1782–August 19, 1829) and thence by descent; sale, London, Sotheby's, June 11, 1997, lot 47; acquired by the J. Paul Getty Museum, Los Angeles (97.PA.36).

EXHIBITED

Paris, Orangerie des Tuileries, *David*, 1948, p. 80, no. 51; Paris, *Gazette des Beaux-Arts, De Watteau à Prud'hon*, 1956, p. 14, no. 23, ill. p. 41.

LITERATURE

A. Th., *Vie de David* (Paris, 1826), p. 163; P. A. Coupin, *Essai sur J. L. David, peintre d'histoire, ancien membre de l'Institut, officier de la Légion d'honneur* (Paris, 1827), p. 54; J. L. Jules David, *Notice sur le Marat de Louis David suivie de la liste de ses tableaux dressée par lui-même* (Paris, 1867), p. 35, no. 34; David

1880, p. 643; Richard Cantinelli, *Jacques-Louis David* (Paris and Brussels, 1930), p. 110, no. 102; Klaus Holma, *David, son évolution et son style* (Paris, 1940), p. 120, no. 10; Louis Hautecœur, *Louis David* (Paris, 1954), p. 127 n. 33; René Verbraecken, *Jacques-Louis David jugé par ses contemporains et par la postérité* (Paris, 1973), pp. 245, 290, pl. 42; Wildenstein 1973, pp. 165, no. 1426, 209, no. 1810, 226, no. 1938; Antoine Schnapper, *David, témoin de son temps* (Paris, 1980), p. 208; Antoine Schnapper, *David* (New York, 1982), p. 208; Marie-Claire Tihon, "Le roman de Mademoiselle Nation chatelaine de Verneuil," *Revue d'information municipale de Verneuil*, 1986, p. 6, ill.; *David 1989*, pp. 20–21, 375, fig. 94 (essay by Antoine Schnapper); *Jacques-Louis David: Portrait of Suzanne Le Peletier de Saint-Fargeau*, sale cat., Sotheby's (London, June 11, 1997).

Suzanne Le Peletier de Saint-Fargeau was the daughter of Michel Le Peletier, the deputy to the National Convention who was slain by a royalist on January 20, 1793, shortly after his vote in favor of capital punishment for Louis XVI. Le Peletier was honored as the first "martyr of liberty"; in homage to his assassinated colleague, David painted a deathbed scene and offered it to the Convention. Le Peletier's orphaned daughter Suzanne was put in the care of the state—hence her nickname, Mademoiselle Nation—although her family wealth was considerable. Ten years later, the young woman had been through a marriage with the son of a Dutch diplomat, motherhood, divorce, and the grievous loss of her two children. When she contacted David to paint her portrait, the twenty-two-year-old heiress is reported to have been on the verge of a love affair with her cousin Léon Le Peletier de Mortefontaine, whom she would marry in 1806.

Whether the portrait was destined as a gift to her new suitor or not, the lack of affectation characterizing it is striking. Gérard, in his portraits of Madame Barbier-Walbonne (Salon of 1798, Musée du Louvre) and Madame Regnaud de Saint-Jean d'Angely (Salon of 1799, Musée du Louvre), had proposed norms as to how fashionable women were to be represented. His second portrait of Juliette Récamier in 1805 (fig. 12) would be the consummate expression in this vein; it represents the sitter not only acknowledging but also welcoming inspection. Suzanne Le Peletier's closed expression has more of an affinity with Constance Charpentier's *Melancholy* (Salon of 1801, Musée de Picardie, Amiens) than with Gérard's beauties. However, she shares their contemporary elegance, as better seen in a miniature portrait by Isabey, who more clearly details her modish hairstyle, cut short in the back and brushed to fall in curls over the forehead, with *oreilles de chien*, or falling locks, framing the face.[1]

Although a monumental presence, Suzanne Le Peletier is not transformed into a sculptural icon as was Henriette de Verninac (fig. 10). The visibility of brushwork and relative roughness of the execution, as well as the choice of a somber background, are particularly effective in giving warmth to the

figure. As if a response to Girodet's exacerbated realism, the play of the material surfaces against one another is subdued but elaborate: muslin dress with lace trim, cashmere stole with embroidered ribbon, and kid gloves with silk lining. The rapprochement with Boilly's close-cropped bust portrait, suggested for Gros's portrait of Jacques Amalric (pl. 7), may also be pertinent here for David. Just before adopting the lavish formal demands of the imperial court, he is receptive to the sense of unmediated humanity expressed by this unpretentious format. Later he resorted to this consciously humble and archaizing mode when representing Angélique Mongez in the double portrait with her husband (1812, Musée du Louvre) and for some of the commissions he accepted in exile.

1. Although the identity of the figure represented in the miniature needs to be confirmed, it appears most plausible; see the illustration from the Madame François Flameng sale catalogue, Paris, Galerie Georges Petit, May 26–27, 1919, lot 182, reproduced in *Jacques-Louis David: Portrait of Suzanne Le Peletier de Saint-Fargeau*, sale cat., Sotheby's (London, June 11, 1997), p. 28.

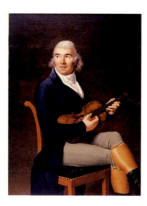

4.
CÉSARINE DAVIN-MIRVAULT (1773–1844)
Portrait of Antonio Bartolomeo Bruni
Oil on canvas, 50⅞ x 37¾ in. (129.2 x 95.9 cm)
The Frick Collection, New York (52.1.160)
Copyright The Frick Collection, New York

PROVENANCE
Antonio Bartolomeo Bruni (January 28, 1757–August 6, 1821) and thence by descent (according to the 1968 Frick Collection catalogue: his wife, Antonia Zucconi, her sister Vittoria Fanny Zucconi, wife of Carlo Bersezio, their son Vittorio Bersezio, and by descent in the Bersezio family); Knoedler Gallery, New York; 1952, acquired as a work of Jacques-Louis David by The Frick Collection (52.1.160).

EXHIBITED
Paris, Salon of 1804, no. 114 (*Portrait del signor Bruni, compositeur, ancien chef d'orchestre de l'opéra Buffa*).

LITERATURE
D. D. [Ducray-Duminil, François Guillaume], "Salon de l'an XIII," *Nouvelles des Arts* 3 (C.D., vol. 32, no. 692, ms. copy, p. 608); "Un Amateur" [Jacques-Philippe Voiart], *Lettres impartiales sur les expositions de l'an XIII* (Paris, Year XIII-1804), letters XXXI–XLIV (C.D., vol. 31, no. 876), p. 58 (letter XXXVII); *The Frick Collection Catalogue* (New York, 1955), vol. 12, pp. 30–33; Raimondo Collino Pansa, "Antonio Bartolomeo Bruni," *La Scala. Rivista dell'opera*, December 1956, pp. 51–52; *The Frick Collection: An Illustrated Catalogue; Volume II, Paintings. French, Italian, Spanish* (New York, 1968), pp. 78–81; Georges Wildenstein, "Un tableau attribué à David et rendu à Mme Davin-Mirvault: 'Le Portrait du Violoniste Bruni' (Frick Collection)," *Gazette des Beaux-Arts*, February 1962, pp. 93–97; Amy M. Fine, "Césarine Davin-Mirvault: Portrait of Bruni and Other Works by a Student of David," *Woman's Art Journal* 4, no. 1 (spring–summer 1983): 15–20.

When she exhibited this portrait of Antonio Bartolomeo Bruni in 1804, Davin-Mirvault presented herself in the Salon *livret* as a pupil of Suvée (as Constance Mayer did in 1801), David, and the miniaturist Jean-Baptiste Augustin (*dit* Dubourg, cousin to J.-B. Jacques Augustin). Since she had submitted only miniatures to the Salon in 1801 and made no mention of David, it can be deduced that her study with the latter began between 1802 and 1804. Making this information public was a way of advertising her heightened ambitions as an artist, as was the full-length self-portrait (lost) she exhibited at the same time as this portrait of Bruni. She was probably encouraged to seek out David by the example of Marie-Guillelmine Benoist, who declared herself his pupil when she showed a series of portraits in 1802 (including cat. 1 in this exhibition).

Davin-Mirvault seems to have been on friendly terms with the Italian composer-musician and his spouse. This is confirmed by frequent references to her and the Bruni couple made by the wife of the sculptor Jean-Guillaume Moitte in her journal for 1805 and 1806. It seems that David occasionally also joined their party: he invited Davin-Mirvault to dinner at his home in December 1805 and again in February 1806, for an evening that prompted this comment from Moitte's wife: "We danced, and it was Bruni who was the violin."[1] This familiarity with the sitter confirms that women painters tended to develop a portrait practice directed in particular to their social and family entourage.

Bruni, who was born in Cuneo, was by 1780 in Paris, where he gained a reputation as a violinist, conductor, and composer. He was particularly successful during the Directory and Consulate. Each year from 1794 to 1801, one or two new operas by him were presented at the Théâtre Feydeau (formerly Théâtre de

Monsieur). During this same period, until 1801, he also conducted the orchestra at the rival Opéra-Comique. An anonymous portrait of Bruni belonging to the city of Cuneo, most probably painted in Paris about 1795, represents him seated at a table with crossed legs, composing a score, pen in hand;[2] he rolls his eyes to appear inspired, much as Giovanni Paisiello does in a portrait by Vigée Le Brun (Salon of 1791, Musée national des Châteaux de Versailles et des Trianons). By 1804, as Davin-Mirvault's portrait suggests, Bruni was more active as a performer than as a composer. She represented him playing pizzicato on his instrument; his askance look evokes an informal situation, as does the loose string. Carefully posed in a manner recalling David's portraits, the figure of Bruni has been compared with that of Pierre Sériziat (fig. 5); the relatively relaxed mood, however, is closer to earlier portraits by David. The execution betrays Davin-Mirvault's effort at achieving convincing anatomical correctness; only in certain parts, such as the hair, does she seem to loosen up her brush. The Salon critics in 1804 were clearly impressed by the visual force and presence of Davin-Mirvault's portrait but regretted the attention paid to material description. They deemed her painting "full of energy and merit" but suggested that a "greater tonal harmony overall might have been desired."[3]

1. *Journal inédit de Madame Moitte . . . 1805–1807*, ed. Paul Cottin (Paris, 1932), pp. 163, 200, 216 (quote).

2. The portrait, which merits study, is reproduced by Raimondo Collino Pansa in his biographical article in *La Scala*, p. 51.

3. D. D., "Salon de l'an XIII": "On aurait désiré plus d'accord dans le ton général"; "Un Amateur," *Lettres impartiales sur les expositions de l'an XIII:* "Ce portrait del Signor Bruni, de madame Davin Mirvault, est plein d'énergie et de mérite: un peu plus d'harmonie dans le ton, et quelque sacrifice de lumière, n'auraient rien laissé à désirer au connaisseur" (p. 38).

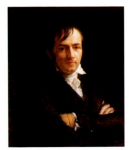

5.

FRANÇOIS GÉRARD (1770–1837)
Portrait of Joachim Le Breton
Oil on canvas, 24¾ x 20½ in. (63 x 52 cm)
Assemblée Nationale, Paris

PROVENANCE

Joachim Le Breton (April 7, 1760–June 9, 1819) and thence by descent (according to the 1993 sale catalogue: the sitter's daughter, Madame Jules Cloquet, to her daughter, Madame Henri Lévesque, to her daughter, Madame Paul Morin, to her son, "oncle des propriétaires actuels"); sale, Monaco, Christie's, December 4, 1993, lot 39; acquired by the Assemblée Nationale, Paris.

EXHIBITED
Never exhibited.

LITERATURE
Oeuvre du baron François Gérard, gravé à l'eau-forte (texte par H. Gérard), esquisses peintes, tableaux ébauchés, compositions dessinées, fac-similé. Portraits à mi-corps et portraits en buste (Paris, 1857), vol. 3, pl. 89 (engraving by Charles Victor Normand, b. 1814); *Lettres adressées au baron François Gérard. . . . ,* ed. Henri Gérard, 3d ed. (Paris, 1888), vol. 2, p. 409 (cited among the "Portraits en buste" and dated 1803), the engraving by Normand from the *Oeuvre* is inserted opp. p. 134; Henri Jouin, *Joachim Le Breton, Premier secrétaire perpétuel de l'Académie des Beaux-Arts* (Paris, 1892), pp. 22–23.

Although neither signed nor dated, the painting, acquired for the French National Assembly, corresponds exactly to the portrait engraved in the mid–nineteenth century for a volume illustrating Gérard's oeuvre and ascribed to 1803. The execution is characteristic of the artist's style at that time. In certain areas, he employs the scumbling learned from his master David but on the whole prefers sharper contours, firmer modeling, and a cooler range of color, notably in the flesh tones. His brushwork is less regular than David's, although never as loose as Gros's nor as tight as Girodet's. The sitter is given an air of steadfastness and determination, not unlike that which Gérard attributed to *Bonaparte* in February 1803 (fig. 24). The austere modernity of the image is striking when compared with

Labille-Guiard's bust-length portrait of Le Breton, dating from Year III of the Republic (1794–95).[1] She paints the sitter turned to one side, vaguely smiling, negligently leaning on the back of the chair with his arms loosely crossed: an image characteristic of the informality and seduction still evocative of the conversational culture of Ancien Régime literary elites. By the time he sat to Gérard, Le Breton wanted to fashion for himself a different identity: his capacity to assume administrative responsibilities.

It is impossible not to relate Gérard's portrait to a major episode in the sitter's biography: his election on February 5, 1803, as *secrétaire perpétuel* of the beaux-arts section of the Institut national. In an alliance with Denon, who oversaw the museum collection and government commissions, Le Breton would use his position to counterbalance David's influence in the art world. To promote an appraisal that minimized David's accomplishments, the two men relied on the painter Vincent, the dominant figure in the beaux-arts section of the institute in charge of a report on the state of contemporary painting.[2] To commemorate his election, Le Breton may have chosen to sit to Gérard precisely because he was not a member of the institute. Nonetheless, he could not have ignored the rivalry existing between David and his former pupil. In 1799 Gérard painted a portrait of Jacobus Blauw (lost) portrayed by David in 1795 (fig. 8); in 1801 another of Juliette Récamier (also lost), right after David abandoned the one he had begun of the famous beauty (fig. 11). The competition was also public knowledge in the commissions for official portraits of the First Consul. In this context, painting Le Breton's portrait was a way for Gérard to consolidate his network of useful relations. The unostentatious bust-length format was evocative of the painter's sympathetic relation to his male sitters. Adopted for *Simon Chenard* (1797, Musée des Beaux-Arts, Auxerre) and *Antonio Canova* (1803, Musée du Louvre), it served to express narcissistic bonds of friendship and mutual admiration.

1. The portrait by Labille-Guiard was also in the sale at Monaco, Christie's, December 4, 1993, lot 38 (sitter misidentified as Jean d'Arcet, corrected in an addendum).

2. Udolpho Van de Sandt, introduction to Joachim Le Breton, *Rapports à l'Empereur sur le progrès des sciences, des lettres et des arts depuis 1789. V. Beaux-Arts*, ed. Denis Woronoff and U. Van de Sandt (Paris, 1989), pp. 17–24.

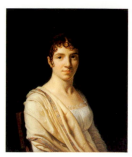

6.

ANNE-LOUIS GIRODET (1767–1824)
Portrait of a Woman
Oil on canvas, 25⅝ x 21¼ in. (65 x 54 cm)
Signed with a monogram and dated, lower right: *ALGDR / 1804*
Smith College Museum of Art, Northampton, Massachusetts
Purchased with the assistance of Eleanor Lamont Cunningham, class of 1932, Fund and the General Purchasing Fund (1956.19)

PROVENANCE

The artist's estate at his death (?); possibly the painting listed by Pérignon in the catalogue of the sale of the estate, April 11–25, 1825, Paris, lot 40, but not sold (perhaps by 1829 in the collection of Adélaïde-Pauline-Virginie Bourguignon née Liger, granddaughter of Adèle Brouet née Mallet [and later the wife of Benoît-François Trioson], see below); . . . ; Wildenstein and Co., New York; acquired in 1956 by the Smith College Museum of Art, Northampton, Massachusetts, with the assistance of the Eleanor Lamont Cunningham, class of 1932, Fund and the General Purchasing Fund (1956.19).

EXHIBITED

Five Drawings by Jacques-Louis David, Smith College Museum of Art, Northampton, 1956, no. 12; *Linear Art of the 19th Century*, Mount Holyoke College, South Hadley, Massachusetts, 1966, no. 23; *19th and 20th Century Paintings from the Collection of the Smith College Museum of Art*, traveling exhibition circulated by the American Federation of the Arts, 1970–72, no. 24; *Art from the Ivory Tower Selections from College and University Collections*, Fred L. Emerson Gallery, Hamilton College, Clinton, New York, 1983, no. 34, ill p. 31; *Corot to Picasso: European Masterworks from the Smith College Museum of Art*, traveling exhibition, 2000–2002, accompanied by Davis and Leshko 2000 (see Literature).

LITERATURE

P. A. Coupin, *Oeuvres posthumes de Girodet-Trioson*, 2 vols. (Paris, 1829), vol. 1, p. lx (see below); George Levitine, "A New Portrait by Girodet," *Art Quarterly* 19, no. 4 (winter 1956): 435–37, ill. 432; *Sele Arte* 5, no. 26 (September–October 1956): 64, ill.; *Arts* 31, no. 3 (December 1956): 17, ill.; Robert O. Parks, "About the Cover," *Smith Alumnae Quarterly* 48, no. 2 (winter

1957): 73; George Levitine, "A New Portrait by Girodet," *Smith College Museum of Art Bulletin*, no. 37 (1957): 16–20; *Girodet, 1767–1824*, exh. cat., Montargis, 1967, unpaginated (cited in the "Biographie" under the year 1804); Stephanie Nevison-Brown, "Girodet: A Contradictory Career," Ph.D. diss., Courtauld Institute of Art, University of London, 1980, pp. 224–25, 233; *1789: French Art during the Revolution*, exh. cat., New York, Colnaghi, 1989, pp. 234–35, 236 n. 7, fig. 12 (entry by Colin B. Bailey); *Musée du Louvre. Nouvelles acquisitions du département des Peintures, 1991–1995* (Paris, 1996), pp. 182, 185 n. 3 (entry by Sylvain Laveissière); Lafont 1999, pp. 53–54, 56 nn. 63–65; John Davis and Jaroslaw Leshko, *The Smith College Museum of Art: European and American Painting and Sculpture, 1760–1960* (New York, 2000), pp. 60–61, ill.

This portrait dated 1804 shows Girodet to have been receptive to the vogue in Paris for dress and coiffure in the antique style, a general trend in Europe during the 1790s, for which David was credited by Parisians who admired the draped figures in his *Sabines* (fig. 3). Girodet may have been familiar with David's *Henriette Verninac* painted in 1798–99 (fig. 10), which best translated into portraiture the spirit of *The Sabines*. The cool, pale colors adopted by both artists reinforce the explicit reference to classical statuary. Although modest in format, Girodet's portrait evidences his particular concern for illusionistic effect and smooth finish. The decorative border on the shawl and the lace trim on the bodice, details that David transcribes with light strokes in *Suzanne Le Peletier* painted the same year (pl. 3), are here given meticulous attention. The controlled surface realism contrasts sharply with the relatively uninhibited brushwork deployed by his former master. In Girodet's portrait, the classical ideal is undermined by this focus on detail, also apparent in the shadows cast by the curls framing the woman's face. The asymmetry of the sitter's eyes, a mannerism alien to David's portraiture, is so pronounced that one wonders whether it is not meant to be constitutive of her identity (see below). Once apparent, this jarring note projects the picture in the direction of a nineteenth-century bourgeois modernity that embraces the imperfections of reality.

The question of the sitter's identity, which first preoccupied George Levitine fifty years ago, although ultimately frustrating, merits a review in light of some recent findings. As is often asserted, it is very possible that this was the portrait described in the catalogue of Girodet's estate sale in 1825 (lot 40): "Portrait d'une femme en buste et de trois quarts. Elle est vêtue d'une robe blanche, et a l'épaule couverte d'un schall; elle est coiffée en cheveux. H. 24p[ouces], L. 20 p[ouces]." The description and the dimensions are right, but it seems that Girodet painted other portraits in many respects similar to this one about the same date. In her thesis, Stephanie Nevison-Brown mentions a portrait identified as Madame Merlin in a private collection, also dated 1804, "which is identical to the Smith portrait, apart from a slight difference in the sitter's garments."[1]

The one in the estate sale should figure in the artist's death inventory, which has recently been published. The entry that best corresponds to it is number 341: "Sur un chevalet un portrait de femme sur un fond bleu," estimated, however, in a bizarre lot with five animal skins, at a very low thirty francs. One problem with this reference, though, along with the vagueness of the description, is that Levitine effectively described the background of the Smith picture as "dark, cool blue," while it has recently been judged "dark green."[2] The portrait in the Girodet sale went unsold; this may mean that it was reserved for the family, which had already chosen to keep a number of other works in the estate for their sentimental value. This is intriguing since in 1829, in his list of Girodet's portraits, for the year 1804 Coupin cites only "Madame Trioson; buste" in the collection of her widowed granddaughter Adélaïde-Pauline-Virginie Bourguignon née Liger, who also owned the *Portrait of M. Trioson, Doctor of Medicine, Giving a Geography Lesson to His Son* (fig. 22). Coupin's identification refers to Marie-Jeanne Mallet, married in 1777 to Pierre Brouet who died in 1786, and then to Trioson in 1788; the daughter born in 1778 married a man named Liger, and their daughter in turn wed Frédéric Bourguignon, who seems to have been an admirer of Girodet's work. The connection between the Smith portrait and the one referenced by Coupin has largely rested on the concordant date of 1804. Anne Lafont, who has documented the Trioson family history, recently discovered, however, that the doctor's wife died at the age of thirty-six on September 12, 1796, after Girodet's return from Italy. Since it seems odd that he would paint her portrait seven or eight years after her death, either Coupin's date or his proposed identification is mistaken. But it may also be that by the 1820s, the details of Marie-Jeanne Trioson's death had become blurred and that the portrait found in Girodet's home was rashly identified by Adélaïde Bourguignon, who owned another portrait of her grandmother. A much earlier portrait of Trioson's wife by Girodet shows her to have been severely cross-eyed, but with features curiously close to those of the woman in the 1804 painting.[3] Although these observations do not much help in discovering the identity of the woman represented, the latter work remains a masterly—and somewhat idiosyncratic—example of the classicizing portrait fashionable during the Consulate.

1. "In the Smith portrait the shawl is white with a pink and yellow edging; the other portrait of Mme Merlin shows a green shawl with a red edging and a yellow belt around the white dress which is cut lower than in the Smith painting. Apart from this, the pose is exactly identical as is the intricate hairstyle and the shadows cast by the curls on the forehead" (p. 224). Linda Muehlig kindly provided me with this reference.

2. Valérie Bajou and Sidonie Lemeux-Fraitot, *Inventaires après décès de Gros et de Girodet. Documents inédits* (Paris, 2002),

p. 251. Lemeux-Fraitot (p. 336) asserts that this was the unfinished portrait of the comtesse de Lagrange on which Girodet was working at the time of his death. However, it is clear from the various listings of unfinished female heads and portraits, always qualified as *ébauches* in the inventory and the sale catalogue, that this painting was very probably finished. Differing with Levitine (1956, p. 437), the authors of the Smith College Museum of Art catalogue (2000) describe the background as "dark green." It seems to range from deep blue to deep blue-green, depending on the light.

3. In his testament, Doctor Trioson left a "bonbonnière" decorated with a portrait of Madame Trioson to her granddaughter (Bajou and Lemeux-Fraitot, as in n. 2, p. 202). Lafont reproduces the earlier portrait of Marie-Jeanne Trioson in a private collection (1999, p. 54, fig. 13). Although Girodet seems to have favored ocular asymmetry (cf. *Hortense de Beauharnais* in the Rijksmuseum, Amsterdam), the discordance in the Smith portrait is particularly insistent.

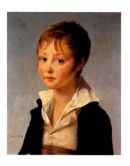

7.

Antoine-Jean Gros (1771–1835)
Portrait of Jacques Amalric
Oil on canvas, 18⅛ x 15 in. (46 x 38 cm)
Signed and dated lower left, scratched into the paint surface:
Gros. 1804 (the last numeral has been tampered with to read also as a 9)
Petit Palais, Musée des Beaux-Arts de la Ville de Paris, Paris
(P DUT, 1303)
© PMVP/Pierrain

PROVENANCE

Jacques Amalric; his wife's nephew, "Mr Cresté" (according to a manuscript inscription on a label on the back: "Portrait de Mr Jacques Amalric, fils majeur de Jac. Amalric et de Jeanne Marie Cécile Gros, sœur du peintre. Ce tableau vient de Mr Cresté, neveu de Madame Jacques Almaric [*sic*]"); . . . ; Jules Cambon by 1913; Roger Cambon by 1936; private collection,

1951; acquired at the sale, Paris, Hôtel Drouot, June 8, 1982, lot 29, by the Musée du Petit Palais, Paris (P DUT, 1303, funded by the arrears of the Dutuit bequest).

EXHIBITED

Paris, Petit Palais, *David et ses élèves*, 1913, p. 47, no. 164 (coll. Jules Cambon, *Ambassadeur de France*); Paris, Petit Palais, *Gros, ses amis, ses élèves*, 1936, pp. 29 ("Avant-propos" by the duc de Trévise), 61, no. 30 (coll. Roger Cambon); Barcelona, La Pedrera (Fundació Caixa Catalunya), *D'Ingres à Bonnard. Collection du Musée du Petit Palais, Paris*, 2003, pp. 24–25 (entry by Isabelle Collet), no. 1, ill.

LITERATURE

Raymond Escholier, *Gros, ses amis et ses élèves. Soixante-dix reproductions dont deux en couleurs* (Paris, 1936), color frontispiece; Raymond Escholier, "Le Baron Gros (exposition du Petit Palais)," *L'Illustration*, no. 4892 (December 5, 1936), unpaginated insert; Gaston Delestre, *Antoine-Jean Gros, 1771–1835* (Paris, 1951), fig. 32 (private collection); Juliette Laffon, *Musée du Petit Palais. Catalogue sommaire illustré des peintures* (Paris, 1981 [*sic*: 1982]), n.p., no. 410 *bis*, ill.; *La Gazette de l'Hôtel Drouot*, no. 25 (June 18, 1982): 18, ill.; Joseph Roy, "Un chef-d'œuvre sans tapage," *L'Express*, June 18–24, 1982, p. 33, ill.; *Connaissance des Arts*, no. 364 (June 1982): 31, ill.; Noëlle Réveillaud-Chabert, "Bilan des acquisitions des musées de la ville de Paris (1981–1988)," *Revue du Louvre et des Musées de France*, nos. 5–6 (1988): 433, 437 n. 12, ill., 433.

According to the inscription on the back of the canvas (cited above), the boy was the painter's nephew, the eldest son of Jeanne-Marie Cécile Gros, his sister, and of Jacques Amalric, a *marchand mercier*, or retailer. Since the couple was married in 1796, it is likely that their son was born soon after and was about six or seven years old at the time of his portrait.[1] The private nature of the commission may explain the absence of any mention of the painting in the two fundamental nineteenth-century monographs devoted to Gros.[2] The conventionality of the pose and format further suggest that it was a gift to his sister, for the artist was usually more concerned to prove his capacity for invention and originality. He represented his sitter in the course of some action: *Paulin des Hours Farel* is shown attempting to catch a bird with his hat (1793, Musée des Beaux-Arts, Rennes), and *Bonaparte at Arcole*, calling his men forward across the bridge (1796, Musée national des Châteaux de Versailles et des Trianons). In other instances, he placed the figure in an evocative setting, as in the plaintive portrait of Christine Boyer (fig. 23). Somewhat stiffly posed, *Jacques Amalric* is closer in spirit to the small bust-length figures Boilly was producing in large numbers since about 1800. These required only a two-hour sitting, and the impression here is also that the portraitist worked quickly. In the decade since he had painted Paulin des Hours Farel in Montpellier on his way

to Italy, Gros had mastered a more transparent and delicate play of the brush, under the influence of the Venetians and Rubens. Informed of this evolution, David from Paris deemed it necessary to urge his former pupil to pay less attention to the latter and more to Raphael.

As mentioned in the essay in this catalogue, Gros seems to emphasize the prettiness of the youth, with his oversize eyes and puckered ruby lips. Such an image of coy innocence is reminiscent of child portraits by Vigée Le Brun, who had encouraged Gros's first steps as a painter, and somewhat mannered like the heads of young girls, and occasionally boys, that Greuze was famous for and was still putting on the market at the time. The strict economy of means deployed, however, as well as the primacy of modeling over the brushwork and the clear contour of the figure set off against a neutral background all betray the painter's training in David's studio and confirm his alignment with the post-Revolutionary generation's care for structure and form. The colors are more luminous than those employed by his master, but the refusal to naturalize and specify the setting is also a trait of the Davidian mode.[3] The sitter's outfit, consisting of an open shirt, a short jacket with wide lapels, and high-waisted breeches, is standard wear for bourgeois youth during the first decade of the century. Boys in similar dress appear in a number of paintings and drawings by Boilly and in the *Young Violinist* exhibited by Jacques-Antoine Vallin at the Salon of 1810 (Musée Marmottan, Paris). The constrained, almost troubled expression of the boy in the latter portrait, evocative of a context of education, performance, and evaluation, could not be further from the apparent insouciance of *Jacques Amalric*.

1. J. Tripier Le Franc, *Histoire de la vie et de la mort du Baron Gros* (Paris, 1880), pp. 113–14.

2. Jean-Baptiste Delestre, *Gros, sa vie et ses ouvrages*, 2d ed. (Paris, 1867); Tripier Le Franc 1880.

3. In the museum's file is a photograph of a copy in a private Boston collection, oval in format, in which the abstract background has been filled in with clouds.

8.

CONSTANCE MAYER (1775–1821)
Self-Portrait of the Artist with Her Father
Oil on canvas, 89 x 70½ in. (226 x 179 cm)
Wadsworth Atheneum, Hartford, Connecticut
The Ella Gallup Sumner and Mary Catlin Sumner
Collection Fund (1989.1)

PROVENANCE

. . . ; Paris, the dealer Brame by 1908; . . . ; Paris, the dealers Jacques Seligmann and Son by 1926; . . . ; (according to the 1989 Sotheby's sale catalogue, sold in Paris, Hôtel Drouot, March 23, 1944, but no sale on that date is recorded); . . . ; Newhouse Gallery, New York; sale, New York, Sotheby's, January 12, 1989, lot 167; acquired at the sale by the Wadsworth Atheneum, Hartford, through The Ella Gallup Sumner and Mary Catlin Sumner Collection Fund (1989.1).

EXHIBITED

Paris, Salon of 1801, no. 238 (*Portrait en pied d'un père et se sa fille. Il lui indique le buste de Raphaël, en l'invitant à prendre pour modèle ce peintre célèbre*); Paris, Lycéum-France [a feminist club founded in 1907], *Exposition rétrospective féminine, tableaux, portraits, dessins, pastels*, 1908, no. 42 (lent by Brame); Paris, Hôtel des Negociants en objets d'art, tableaux et curiosités, *Femmes Peintres du XVIIIe siècle*, 1926, no. 76 (lent by Seligmann and Son).

LITERATURE

Madame Angot au Muséum. Première Visite (Paris, Years IX–X [1801]), p. 18 (C.D., vol. 26, no. 684); Charles Gueullette, "Mademoiselle Constance Mayer et Prud'hon," *Gazette des Beaux-Arts*, May 1879, p. 487; Jeanne Doin, "Constance Mayer," *Revue de l'art ancien et moderne*, January 1911, pp. 53–54, ill. 51; Edmond Pilon, *Constance Mayer* (Paris, 1927), pp. 28–29, 119–20, ill. opp. p. 16, with the indication, "Collection J. Seligmann et fils"; Ann Sutherland Harris and Linda Nochlin, *Women Artists 1550–1950* (New York, 1977; reprint of 1976 Los Angeles County Museum of Art exh. cat.), p. 213; Germaine Greer, *The Obstacle Race* (London, 1979), p. 37; Helen Weston, "The Case for Constance Mayer," *Oxford Art Journal* 3, no. 1

(April 1980): 14–15, ill. 14; *La femme artiste d'Elisabeth Vigée Le Brun à Rosa Bonheur*, exh. cat., Mont-de-Marsan, Musée Despiau-Wlérick, 1981, p. 40; Susan Hood, "Re-Reading Constance Mayer's *Full-Length Portrait of a Father and His Daughter*," *Southeastern College Art Conference Review* 12, no. 2 (1992): 80–86; Jean-Pierre Cuzin, "Raphaël et l'art français: Introduction au catalogue," in *Raphaël et l'art français*, exh. cat., Paris, Grand Palais, 1983, pp. 56–57, 65, fig. XXVII; *Prud'hon ou le rêve du bonheur*, exh. cat., Paris, Grand Palais, ed. Sylvain Laveissière, 1997, pp. 176, 179, fig. 118a; Susan Hood, "Constance Mayer: de quoi avait-elle l'air et pourquoi est-ce important?" *Pierre-Paul Prud'hon*, papers from a conference held at the Musée du Louvre, 1997, ed. S. Laveissière (Paris, 2001), pp. 137, 139–40, 144 n. 24.

With this painting, Constance Mayer expressed both her strong attachment to her family and her aspiration to artistic independence. Brought up by her mother and recognized by her father only in 1789 when she was fifteen, she seems to have been very affectionate toward her parents. She exhibited for the first time at the Salon in 1796, with a self-portrait "presenting the sketch of the portrait of her mother" who had died in 1790. The self-portrait with her father, painted in 1801, confirms her relative social isolation and the importance of the support she received at home. She represents herself standing to one side, as if meditating on her father's words; he is placed in the center of the composition, as the holder of knowledge and experience, a sage seated on an elegant "curule" armchair by Georges Jacob.[1]

In spite of this focus, the space is clearly the realm of the painter and the father is only a visitor. The canvas on the left is set to be worked on, a painting box is open on the right, there are drawings, and on the wall are two casts, which were more clearly visible before the picture was cut down on the right. To this typical paraphernalia of practice, Mayer associates not only her perorating elder but the bust of Raphael, the pivotal artist in the installation of the museum in the Louvre.[2] Whatever the content of the paternal lesson, the mood that reigns is one of utmost seriousness. By affirming so explicitly her sense of dedication, Mayer seems to want to counter the accusations of amateurism so often leveled against women artists. The scale of the painting is particularly effective in conveying her ambition. The attention she accords to the description of the interior is more typical of small-scale scenes in the Dutch tradition. On this grand scale, however, the filiation is rather with aristocratic portraiture of the Ancien Régime, in which the setting served to affirm status. Since the late seventeenth century, rarely if ever had an artist's working space been represented on this scale in France. As suggested by Boilly's *Reunion of Artists in Isabey's Studio* at the Salon of 1798 (fig. 2) and Jean Broc's imaginary *School of Apelles* in 1800 (Musée du Louvre), artists during the Directory and Consulate were increasingly fascinated by their professional milieu and its glorious history. Although

the theme of the visit to the studio was not uncommon in England, the novelty of Mayer's picture, apart from the scale of the representation, was the sincere revelation to the Salon visitors of the private, introspective facet of artistic activity. Unlike the social climbers who compose for themselves public roles at Isabey's, Mayer evokes with remarkable honesty the combination of heroism and anxiety with which she appears to live out her professional commitment.

1. A very similar armchair form is reproduced by Pierre Arizzoli-Clémentel, "Les arts du décor," in Bordes and Michel 1988, p. 292, fig. 259 ("après 1792").

2. Martin Rosenberg, "Raphael's *Transfiguration* and Napoleon's Cultural Politics," *Eighteenth-Century Studies* 19, no. 2 (1985–86): 180–205.

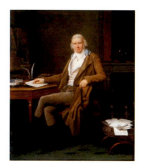

9.

ADÈLE ROMANY, ALSO KNOWN AS ADÈLE DE ROMANCE (1769–1846)
Portrait of Louis Etienne Vigée
Oil on canvas, 23⅞ x 19¾ in. (60.5 x 50 cm)
Signed and dated lower left[1]: *Adele Roma . . . / 1800*
Private collection

PROVENANCE

Louis Vigée (1758–1820); . . . ; collection of the Parisian dealer René Weiller; sale, Monaco, Sotheby's, December 7–8, 1990, lot 57; acquired by P. & D. Colnaghi & Co. Ltd., London; private collection.

EXHIBITED

Paris, Salon of 1800, no. 324 (*Portrait du C[itoyen] Vigée*).

LITERATURE

Master Paintings, 1400–1800, exh. cat., ed. Donald Garstang, London, Colnaghi, 1993, p. 87, ill.

Louis Etienne Vigée, the younger brother of the portrait painter Elisabeth Vigée Le Brun, was a rising star in Parisian literary circles on the eve of the French Revolution. He authored successful plays, *Les Aveux difficiles* in 1783 and *L'Entrevue* in 1788, and became editor of the *Almanach des Muses* in 1789. Socially, he mingled in the same milieu as his sister, enjoying the protection of Charles-Alexandre de Calonne (fig. 18), the comte de Vaudreuil, and the comtesse de Provence. Whereas Elisabeth emigrated with her aristocratic friends, Etienne embraced the Revolution and put his poetry at the service of the republican cause. After being imprisoned for several months during the Terror, he secured an administrative position after Thermidor and managed to restore his social standing. He began once again to publish poems, giving them a more introspective and personal tone. Hoping to supplant the aging Jacques Delille, he regularly recited his verses at fashionable gatherings during the Consulate.

Adèle Romany's portrait celebrates the self-confidence Vigée had regained by 1800. He is represented in a comfortable interior, decorated in a style that is contemporary but restrained. The colors are muted but offer a rich palette of browns, grays, and greens, accented only by the light blue of the collar. Since Gérard's portrait of Isabey (fig. 7), such subdued chromatic harmonies, which came to be associated with an ethos of artistic dedication, regularly serviced strategies of self-promotion at the Salon. This moderation also characterizes the furniture, when compared with the showpieces that attracted other portraitists (figs. 9, 22, 32). The focus is not on the family man but on the author, and not on the inspired poet but on the committed writer. On a stool figure prominently the texts of *L'Entrevue*, which had established his reputation, and of *Ma Journée*, a short poem he had published in the Year VII (1798–99). He is represented pointing to a new manuscript, *Mes Conventions*, in press at the time (Year IX, 1800–01), for which Romany composed the frontispiece, a scene of bourgeois charity toward the rural poor. Although his sister would not return from emigration until 1802, she had sent two portraits to the Salon in 1798: Vigée's choice of a woman painter working in a minutely descriptive style may have been a way to dissociate himself publicly from his sister's idealized conceptions, which many at the time judged outmoded.

Romany occasionally revived the codes of portraiture associated with the aristocratic imaginary of a recent past, although she seems to have been more interested in assimilating contemporary trends. Her personality and professional strategy were somewhat discreet and fundamentally responsive: she made no attempt to impose herself through the affirmation of a distinctively personal style. She follows a singularly erratic course, well reflected in the idiosyncratic manner of signing her pictures and listing her name in the Salon *livrets*.[2] Throughout her career, Romany proved her ambition by painting life-size portraits, including the striking *Jean Dominique Fabry Garat Playing a Lyre* (Salon of 1808). Like her genre scenes *à l'antique* (*A Young Woman Teaching Her Lover to Play the Lyre*, Salon of 1802), such works are animated by a graceful sense of line and form rarely present in the small formats and attest to her study with Jean-Baptiste Regnault.[3] About the time she portrayed Vigée, she apparently favored this mode since she painted several other figures in an interior, but during the Empire, whenever she adopted this reduced scale appreciated by her middle-class clientele, she usually preferred an outdoor setting that allowed her relatively more freedom to invent.

1. According to the 1993 Colnaghi catalogue (see Literature); signature and date, on the baseboard behind the table, are very indistinct.

2. Her maiden name was Marie-Jeanne Mercier, until her father, the marquis de Romance, legitimated her in 1778 as Marie-Jeanne de Romance. She later married the miniaturist François-Antoine Romany, whose name she generally adopted, even after their divorce, and by 1793 changed her first name to Adèle. Carlo Jeannerat, "L'auteur du portrait de Vestris II, Adèle de Romance, et son mari, le miniaturiste François-Antoine Romany," *Bulletin de la Société de l'histoire de l'art français*, 1923, pp. 52–63; Margaret A. Oppenheimer, "Four 'Davids,' a 'Regnault,' and a 'Girodet' Reattributed: Female Artists at the Paris Salons," *Apollo*, June 1997, pp. 38–40.

3. *Une jeune femme donnant une leçon de lyre à son amant* was sold in Paris, Hôtel Drouot, June 14, 1996, lot 47. The portrait of Fabry Garat (the son of the more famous politician Dominique-Joseph Garat and the brother of the singer Pierre Jean Garat) was sold at Senlis, December 13, 1998, lot 66.

Bordes et Michel 1988
Bordes, Philippe, and Régis Michel, eds. *Aux armes et aux arts! Les arts de la Révolution 1789–1799*. Paris, 1988.

Bruun Neergaard Year IX-1801
Bruun Neergaard, Tønnes Christian. *Sur la Situation des Beaux-Arts en France, ou Lettres d'un Danois à son ami*. Paris, Year IX-1801.

Carr 1807
Carr, John. *The Stranger in France; or, A Tour from Devonshire to Paris*. London, 1807 (first edition 1803).

C.D.
Collection Deloynes, 63 volumes of printed texts and manu-script copies concerning the arts. Paris, Bibliothèque nationale de France, Département des Etampes et de la Photographie, edited in microfiche; vol. 24 missing since 1938.

David 1880
David, J. L. Jules. *Le peintre Louis David, 1748–1825. Souvenirs et documents inédits*. Paris, 1880.

David 1989
Jacques-Louis David, 1748–1825. Exhibition catalogue edited by Antoine Schnapper, Arlette Sérullaz, and Elisabeth Agius-d'Yvoire. Paris, Musée du Louvre, and Versailles, Musée national du château, 1989.

De David à Delacroix 1974
De David à Delacroix. La peinture française de 1774 à 1830. Exhibition catalogue edited by Pierre Rosenberg. Paris, Grand Palais, 1974.

Farington 1979
The Diary of Joseph Farington. Edited by Kenneth Garlick and Angus Macintyre. *August 1801–March 1803*. Vol. 5. New Haven and London, 1979.

Greatheed 1953
Greatheed, Bertie. *An Englishman in Paris: 1803*. Edited by J. P. T. Bury and J. C. Barry. London, 1953.

Halliday 1999
Halliday, Tony. *Facing the Public: Portraiture in the Aftermath of the French Revolution*. Manchester, 1999.

Hunt 1992
Hunt, Lynn. *The Family Romance of the French Revolution*. Berkeley and Los Angeles, 1992.

Kotzebue Year XIII-1805
Kotzebue, Auguste. *Souvenirs de Paris, en 1804, traduits de l'Allemand sur la deuxième édition*. Edited by René-Charles Guilbert de Pixérécourt. 2 vols. Paris, Year XIII-1805.

Lafont 1999
Lafont, Anne. "Girodet et Trioson: les tableaux de l'amitié." *Revue de l'Art*, no. 123 (1999): 47–56.

Lajer-Burcharth 1999
Lajer-Burcharth, Ewa. *Necklines: The Art of Jacques-Louis David after the Terror*. New Haven and London, 1999.

Portraits by Ingres 1999
Portraits by Ingres: Images of an Epoch. Exhibition catalogue edited by Gary Tinterow and Philip Conisbee. London, The National Gallery; Washington, D.C., National Gallery of Art; New York, The Metropolitan Museum of Art, 1999.

Pressly 1981
Pressly, William L. *The Life and Art of James Barry*. New Haven and London, 1981.

Reichardt 1804
Reichardt, Johann Friedrich. *Vertraute Briefe aus Paris geschrieben in den Jahren 1802 und 1803*. 3 vols. Hamburg, 1804.

Watelet and Lévesque 1972
Watelet, Claude-Henri, and Pierre-Charles Lévesque. *Dictionnaire des arts de peinture, sculpture et gravure*. 5 vols. Paris, 1792. Reprint. Geneva, 1972.

Weston 1998
Weston, Helen. "Working for a Bourgeois Republic: Prud'hon, Patronage and the Distribution of Wealth under the *Directoire* and Consulate." In *Art in a Bourgeois Society, 1790–1850*, edited by Andrew Hemingway and William Vaughan, pp. 154–77. Cambridge, 1998.

Wildenstein 1973
Wildenstein, Daniel, and Guy Wildenstein. *Louis David. Documents complémentaires au catalogue de l'œuvre de Louis David*. Paris, 1973.

Wrigley 1993
Wrigley, Richard. *The Origins of French Art Criticism: From the Ancien Régime to the Restoration*. Cambridge, 1993.